Declutter
YOUR PHOTO LIFE

Curating, Preserving, Organizing, and Sharing Your Photos

ADAM PRATT

Declutter Your Photo Life

Adam Pratt

chaostomemories.com

Project editor: Jocelyn Howell
Project manager: Lisa Brazieal
Marketing coordinator: Katie Walker
Book interior and cover design: Aren Straiger
Layout and type: Danielle Foster

ISBN: 978-1-68198-875-7
1st Edition (1st printing, September 2022)
© 2022 Adam Pratt
All images © Adam Pratt unless otherwise noted

Rocky Nook Inc.
1010 B Street, Suite 350
San Rafael, CA 94901
USA

www.rockynook.com

Distributed in the UK and Europe by Publishers Group UK
Distributed in the U.S. and all other territories by Ingram Publisher Services

Library of Congress Control Number: 2022937114

This book is printed on acid-free paper.
Printed in China

About the Author

ADAM PRATT loves people, photography, and a good story! He spent the last twenty-five years at the intersection of creativity and technology, including twenty-two years at Adobe, where he worked on the Creative Cloud team. He's a professional photo organizer, software trainer, and photographer. He's also the founder of Chaos to Memories, where he helps people enjoy their photos again by turning their photo chaos into precious memories they can enjoy and share.

Contents

PHASE 1: Gather

PHASE 2: Preserve

PHASE 3: Organize

PHASE 4: Share

PHASE 5: Maintain

Overwhelmed by Photos

In 1986 my Uncle Ray and Aunt Doris bought me my first camera, a Minolta Weathermatic A. It was a waterproof point-and-shoot camera that used 110 film and was the perfect rugged camera for an eleven-year-old boy to take to camp, to the beach, and on vacation to Yosemite National Park. I would often shoot an entire roll of film in a week as I explored the world around me and captured my early memories.

In 1988 I started using my mother's Asahi Pentax K1000. This was a classic 35mm SLR that sold more than three million units, and it was the camera I used to learn about the interplay of aperture, shutter speed, and film speed. I learned to develop my own film in the bathroom, and in my eagerness to improve my photography, I sometimes shot an entire roll of film in a day.

In 2001, Russell Preston Brown, a Senior Principal Designer at Adobe, gave me a Canon digital camera as a gift to celebrate the birth of my first child. That 2.1-megapixel camera was an amazing way to capture his early years. On important days like Christmas and birthdays, I often shot one hundred or more images.

For Christmas 2003 I bought my first digital SLR, a Canon Digital Rebel. It was mind-boggling that I could afford a 6.3-megapixel digital camera with interchangeable lenses for less than a thousand dollars. By today's standards, that camera is archaic, but at the time it was an impressive piece of gear and an amazing breakthrough in the camera industry.

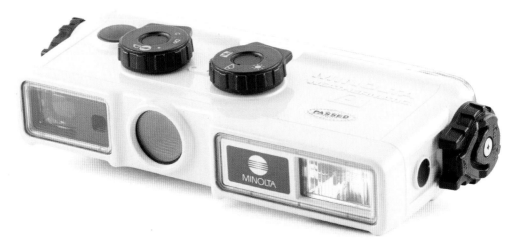

FIGURE 1.1 The first camera I owned, a gift from my Aunt Doris and Uncle Ray, was a bright yellow Minolta 110 Weathermatic A. This rugged, underwater camera was sold in the early 1980s and shot 110 film cartridges.

FIGURE 1.2
The Pentax K1000 was the first "real" camera I used as a young photographer. It was my mother's camera, and I fell in love with it. I was rolling my own film, processing it in my bathroom, and printing contact sheets of my work at age eleven.

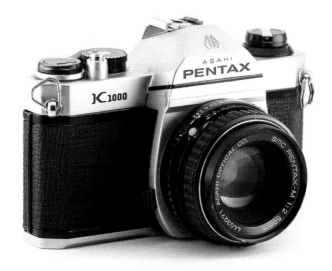

FIGURE 1.3
This Canon PowerShot S110 Digital Elph came bundled with an 8MB memory card that could hold twelve JPEG images at a time. This camera captured thousands of memories of the early life of my young children and will always hold a special place in my camera collection.

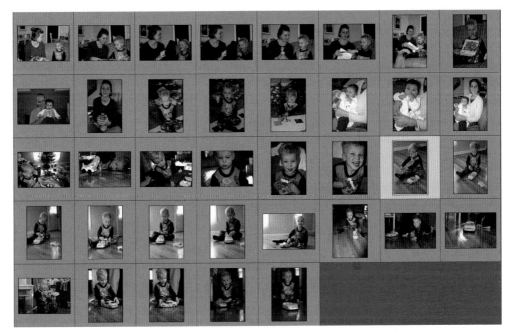

FIGURE 1.4 Christmas 2003 was our family's first holiday with my new Canon Digital Rebel with a whopping 6.3-megapixel sensor. I took a lot of photos that year.

My photographic world exploded with my Canon Digital Rebel. My kids were three and one at the time, and there's nobody more snap-happy than a parent of toddlers. The first year I owned that camera I shot more than 50,000 exposures. In fact, I took so many photos that I wore out the shutter (one of the only mechanical parts of a DSLR), and I had to have it replaced by Canon. The transition to digital was a new world of creativity and learning for me.

But I wasn't the only one making the switch. In the early 2000s, people around the world were transitioning from film cameras to digital. Not everybody was dropping a grand on a DSLR or shooting 50,000 photos a year, but with the accessibility and low cost of digital photography, we all started shooting more.

On one hand, this digital revolution was amazing because we were creating more photos, capturing more memories, and enjoying more creativity. The transition to digital photography included the freedom to experiment, learn, and grow as photographers. But because we weren't paying for film, processing, and printing, we picked up bad habits like using burst mode and selfie sticks, and taking photos of our lunches. Despite having access to higher-quality cameras than ever, most of us are still taking more bad and thoughtless photos than we want to admit. We're burying ourselves beneath our own photo backlogs, and the joy of digital photography has become an overwhelming burden for many.

But I have good news—this is where *Declutter Your Photo Life* comes in. In this book, you're going learn to declutter your photos, streamline your workflow, and enjoy your memories again!

Chaos to Memories

I've spent the last thirty years at the intersection of photography, design, and technology. My mind is wired for organization, efficiency, and stories, which means my family photos are thoughtfully curated, thoroughly organized, and instantly searchable. After developing a system for managing my digital photos, I turned my attention to the past and scanned and organized all my family photos back to the year 1904, digitized all our Super 8 film reels, and converted all our home movies. It didn't feel right to do only half of the family tree, so my next step was to complete the same project for my wife's side of the family.

I enjoyed the process and was thrilled with the result: a Family Photo Archive that was sorted, searchable, shareable, and secure. As I talked with friends about my project, I realized everybody wanted their photos preserved and organized, but nobody knew where to start. What was overwhelming for others was intuitive for me.

That's when I started scanning and organizing photos for other families. What began as a personal project became a passion and developed into my profession. I founded Chaos to Memories in 2017, and the business has grown beyond my expectations every year. We scan photos of all types (prints, negatives, slides, etc.), convert video tapes, digitize film reels,

organize digital photos, and turn those organized memories into creative projects such as photo books, slideshows, and wall art.

My staff and I do all our work by hand and on-site in our Chicago studio. Organizing millions of photos every year for clients across the country gives me a unique perspective on the content and volume of photos that people take. Our clients typically take ten times more photos than they did just ten years ago, and at the same time, I'm witnessing a dramatic drop in quality. Below is a screenshot of a real client project that included bursts of hundreds of completely black photographs. These have been in this family's Apple iCloud Photo Library for years, and if these duds haven't been deleted, I suspect the good shots haven't been enjoyed either. This glut of bad, uncurated, and unshared photos has left us all feeling overwhelmed by our digital backlog.

FIGURE 1.5 Keeping several hundred completely black photos in in a photo archive is a silent cry for help—not only to take better photos, but also to better curate and organize the keepers.

Our average photo organizing client has more than 100,000 digital photos, and some of our clients have as many as five to ten million digital photos. When it comes to physical photos, our average client has 10,000 pieces in their family collection. My personal photos and these massive client collections have been the proving ground for the organizing workflow I've developed and refined over the last twenty-five years.

The Power of Photography

Before I introduce the five steps of my photo organizing workflow, we need to talk about the *why* of organizing your photos. Clarifying your why is important because at some point in the process you're going to wonder why you're doing this. You're probably going to get frustrated and want to give up! This is completely normal, and that's when you need to remember why you're doing this. Your why should be powerful and memorable enough to be your sustaining motivation.

I organize millions of photos every year, and through that experience I've found ten reasons why people spend the time or hire a trusted expert to organize their photos:

1. These aren't just family photos, they're family memories. We're talking about first teeth, first steps, first days of school, and first dates. This is why you'd run back into a burning house for your wedding album and why families decide these memories are worth preserving. On the following page are a few of my favorite photos that I wouldn't want to be without.

2. You take more photos than ever, but they've become a burden. You feel over-whelmed and don't know where to start, but you know you want to enjoy your photos again. There's an insidious side to this that really bothers me. Photos are supposed to capture memories so we can relive, share, and enjoy them, but instead they're overwhelming us. I want you to feel joy again about your photos, not be overwhelmed.

3. You want to share your photos with your children, extended family, and friends because they're a powerful way to connect with those you love. Photos help people to understand where they come from, to count their blessings, and to remember the loved ones they've lost. Photography is like a time machine that lets you visit people, places, and events that you can't reach any other way.

4. In order to share your photos, you have to be able to find your photos. Most peo ple can't remember if a certain photo is on their computer, phone, tablet, or in the cloud. If you can't find a photo, then you don't really have it, do you?

5. You want to search for your photos instead of browsing endlessly. We search Amazon for products, websites for plane tickets, and mobile apps for sports scores. Wouldn't it be great to search for that great vacation photo with all the cousins in-stead of scrolling through thousands of images hoping you can find it again?

6. You want everybody in the family to have access to your photos instead of burying them in a box or hiding them on a hard drive. These projects are usually completed by one very determined person, but the recipients can span multiple generations, families, and locations.

"Shaving" with Dad

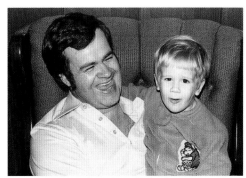

Cuddling with Dad

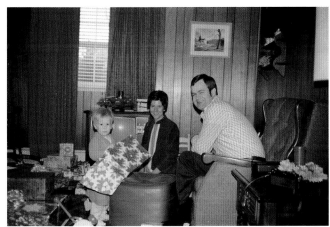

Christmas with Mom and Dad

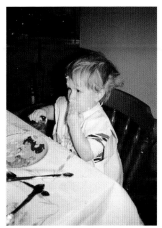

Smearing mashed potatoes all
over my face at Easter dinner

FIGURE 1.6 Family memories

7. You want to access your family photos on any computer, tablet, smartphone, or web browser. Your photos are more important than your choice of computer or phone, and you want to be able to access them anywhere.

8. You want your physical photos including prints, slides, negatives, and albums to be safe. You worry about fires, floods, tornadoes, and hurricanes. You're concerned about mold, decay, and other scary stuff that can damage your photos.

9. You want your digital photos backed up because you don't want to have a heart attack if the hard drive dies, the laptop gets stolen, or you lose your phone.

10. You want your photos for today and future generations. You want to remember, and be remembered.

Activity: Your Why

This list represents the ten most common reasons our clients decide to work with a professional photo organizer. Some other common motivations to get this project done can include a child graduating or getting married, a spouse retiring, or a parent with fading health. Remember that you can do all or some of this project yourself, or you can work with an expert you trust.

But before you move on to chapter 2, I hope you'll take a minute to write down your top three reasons for organizing your photos. Writing these down will solidify your convictions and strengthen your motivation on the days you're tempted to give up.

I'm committed to organizing my photos because....

2

Workflow Overview

The number one reason our photo organizing clients contact us is that they feel overwhelmed. It's not that they don't care about their photos or are unwilling to spend the time and money to get them organized; it's just that they don't know where to start. While many people are willing to tackle this project, they fear that if they don't do it right the first time, they'll have to start over from scratch. In other words, they know this is going to be a big project, but they're afraid of learning halfway through that they scanned at the wrong resolution or named their files in a bad way. Most people dread the thought of organizing their photos, so imagine having to do it twice!

I had a client visit me a few years ago who had already used a popular online service to scan her photographs, and she wanted me to review those files. The first thing I noticed was that the resolution and quality of her scans were unusually low. They looked barely acceptable on a computer screen, and I had to break the news to her that while she got a low price on the scanning, she also got low quality. The resolution was so low that she couldn't even make a 4 x 6-inch print from the files. I felt bad for my friend and angry at the company for doing such terrible scanning.

Another common mistake is using an organization system that doesn't support industry standards or scale with larger collections. Many people tell me about the organizing they've done with services such as Google Photos, Amazon Photos, or Apple Photos. Unfortunately, they don't realize that most of those faces, places, and keywords they tagged are accessible in those systems only and are not permanently attached to their photos. This can be a

major problem when the company changes its service or you want to use a different kind of phone or computer. I deeply resent the idea that your photo organization and memories would be held hostage by a big tech company, and it's why we at Chaos to Memories only use software and recommend services that support open standards.

I decided to write this book because of all the times I've had to break bad news to people about their photo organizing plans. I want to spare you the wasted time, the second-guessing, and the unnecessary rework that happens so often with photo organizing projects that don't follow industry best practices and a good plan.

Core Pillars of the Photo Management Workflow

At Chaos to Memories, we call this organizing plan a "workflow," which is a series of steps that we use every time for every project. I've been developing and refining this workflow for twenty-five years, and it's the foundation of everything we do at Chaos to Memories. Our photo management workflow is built on three core pillars:

Efficiency: Our average client has 10,000 physical photos and more than 100,000 digital photos. Considering these numbers, it quickly becomes obvious that being as efficient as possible is necessary if you're ever going to finish your photo organizing project. Little steps that can save a few seconds per photo add up quickly. Doing steps in a specific order can save you even more time.

Quality: I love organizing photos, but I realize it's a tedious process that most people only want to do once. Therefore, I want to help you get it done right the first time at the highest quality. With simple tasks such as scanning photos, deleting duplicates, or assigning searchable keywords, there are important choices to make so that you retain the quality you expect and don't accidentally degrade your photos.

Consistency: Because these projects are often big and ongoing, I've found that one of the most important factors for success is feeling a sense of progress and accomplishment. And the best way to achieve this is by using a consistent workflow. Instead of bouncing around between lots of different tasks, we follow the same workflow steps with every batch of photos. That means we always know when we're done with a batch or phase of the project. Consistency leads to progress, progress leads to confidence, and confidence leads to success!

Whether you realize it or not, almost everybody uses some process to manage their photos. But that doesn't mean their process is thorough, efficient, or aligned with industry best practices. One of the biggest mistakes we see when people organize their photos is that their workflow is not efficient. The worst example I can remember is a client who brought us a large digital photo organizing project. She had fifty-seven backups of a set of 17,000

photos. She did have a plan, but it certainly wasn't efficient. The day I deleted all those duplicates was an important milestone in her project and a lesson for all of us. We need a better plan, a consistent and repeatable workflow for organizing our photos.

Five-Step Workflow

At Chaos to Memories, we use the following five-step workflow on every client project, and it's the functional outline for the rest of this book. For now, I'll introduce you to the five main phases so that you can see how they work together in a comprehensive sequence. Then, later chapters will dive into the details of each phase.

Gather Preserve Organize Share Maintain

1. **Gather:** Every project, without exception, starts with gathering. This is true of both digital projects—which might involve hundreds of thousands or even millions of photos from computers, hard drives, discs, and memory cards—and physical photo projects, even if it's as simple as gathering an envelope or shoebox of photos to scan. There's no avoiding the gathering phase of a photo organizing project, and one of the major motivating factors is cost.

 Everybody wants to know how long their project will take and how much it will cost. It's a fair question, but it's not one I can answer without knowing more about the project. It's sort of like asking, "How much does a house cost?" There's a huge range on the price tag of a house—anywhere from $50,000 to $50,000,000, or more. Similarly, there's range of costs in photo organizing projects. We work with clients who spend a few hundred dollars to scan a shoebox of photos, and we've worked with clients who spend tens of thousands of dollars on extensive, multi-generational archives. Whenever somebody asks me how much a photo organizing project will cost, my answer is always, "You show me." What I mean is that I want the client to show me what they have so that together we can get a sense of the scope and complexity of the project. Until we gather everything in one place, we don't even know what we're dealing with.

 We also deduplicate digital collections early in the process so that we don't waste time converting or organizing photos that we would just throw away later.

 The last thing I'll mention about the gathering phase is that the more thorough you can be up front, the more accurately you can understand the scope of the project.

If we organize all of a client's digital photos and at the very end of the project they surprise us with another hard drive of images, we can certainly handle that, but it will increase the scope of the project and decrease the efficiency.

2. **Preserve:** After you gather all your photos to be organized, the next phase of the workflow is all about preservation. My definition of preservation is broad and encompasses various steps depending on the kind of photos you're dealing with. For example, if you're working with physical photos such as prints, negatives, and slides, then getting those scanned as high-resolution and high-quality digital files is an important step in preserving those memories. If you're dealing with digital photos, then an important aspect of preservation might include converting obsolete file formats to modern and universal file formats. The goal is to have high-quality, high-resolution images that are accessible today and long into the future.

3. **Organize:** After you've gathered, deduplicated, and preserved your files, it's time to curate and organize the photos you're going to keep. From an efficiency perspective, this phase demands special attention because organizing is the most time-consuming phase of the workflow. But at least you will be organizing only the photos that you care about, right? The essence of my organizing system is a chronological sort combined with searchable metadata that's embedded inside your digital files. You might not know every date or every name, but perfection isn't the goal.

 We'll explore this in more detail in later chapters, but you'll discover that this combination of date-based organization and searchable metadata is the most robust and flexible way to organize your photos. We use Adobe Lightroom Classic for all our photo organizing clients, but every step in the workflow and everything you'll learn in this book relies on industry standards and isn't tied to just one software, phone, or computer. This is supremely important to me because I don't want you and your photos to be trapped in a system that depends on only one app, one company, or one cloud service. Your photographs and memories are too important to be held hostage by one company that might change product direction or even go out of business, so I'll teach you how industry standards are your best option for legacy archives and future access.

4. **Share:** Organizing photos with searchable metadata is a big project, but the payoff is totally worth it. There's no time this becomes more apparent than when you're ready to share your photos. Whether you want to post photos on social media, create a photo book of your family vacation, or contribute photos to a slideshow for your best friend's retirement party, a searchable photo archive makes these projects quick and easy.

 A good example of this is when my oldest child was headed off to college. I realized I should use my thoroughly organized Family Photo Archive to make a photo book celebrating his first eighteen years of life and this major milestone. Because my photos are sorted chronologically and easy to search, I quickly isolated all the photos

of my son and chose about 300 of my favorites. That selection process took me only an hour.

Then I used those 300 photos to design a beautiful photo book for him. Because all the photos were clearly named and sorted chronologically, I was able to design a 100-page book for him in about an hour. I reviewed the design, exported a PDF, and uploaded the files to one of my favorite book printers. This entire project, from start to finish, took less than three hours, and sharing these photos in such a meaningful way was possible because the photos were organized, searchable, high-resolution, and easy to work with.

If you happen to be reading this book as a professional photographer, I want to point out that a searchable photo archive also makes it easier to sell products and license images. It doesn't matter whether you're a grandmother, a professional photographer, or in corporate marketing, searching is always easier than browsing when you want to find your photos fast. For this phase, you'll learn best practices for searching, practical ideas for sharing, and secure ways to access your searchable photo archive from anywhere.

5. **Maintain:** The dirty little secret of photo organizing is that even when you're done, you're never really done. Unless you're working on a specific historical photo archive, people keep taking new photos. The good news is that the workflow you'll learn for organizing your old photos is the same workflow you'll use to organize and maintain new photos yet to be taken.

 This is a perfect example of the importance of a consistent workflow. You'll use the same steps whether you're organizing photos you took twenty years ago or twenty minutes ago, and these new habits will quickly become second nature. This consistent workflow gives you peace of mind for today and an accessible photo archive for generations to come.

Important Tips for Photo Organizing

As you think about the five phases of this photo organizing workflow, consider these tips:

1. **Follow the Prescribed Order:** Follow the workflow in this book in the order it's written. People who know me well will tell you that I'm very thorough and methodical, and this book is no different. You'll get the best results in the least amount of time if you follow the sequence of this book. I've tried it other ways, and I always come back to these steps in this order.

2. **Don't Skip Steps:** If you try to skip steps in the workflow or shortcut the process, it will lead to more work, unnecessary confusion, and lots of frustration. You might not want to be as detailed as I am with searchable keywords (see chapter 12), but stick to the plan and you'll thank me later.

3. **Think Big Picture:** Try not to focus too much on any one step, but see how the sequence of steps creates a cohesive workflow. The pillars of quality and efficiency become clear when you see this workflow as a complete system that can handle any kind of photo or video format from any generation, camera, or company.

In the next chapter, you'll learn about the hardware and software I recommend for any photo-organizing project. I'll save you hours of research as you assemble a comprehensive digital toolkit for the project ahead.

3

Software and Hardware

Whether you're organizing digital photos, physical photos, or both, you're going to rely on the latest computer hardware and software to make the process as efficient as possible. Lucky for you, I'm constantly testing new hardware, software, and cloud services to find what works best in terms of speed, reliability, and support for industry standards. I'll share the what and why of all my recommendations so you can make informed decisions about what to buy for your project and budget.

I hear from a lot of people who want to declutter and organize their photos but don't want to learn anything new. I don't think that's you, because you bought this book and are spending the time to read it. Even if you're intimidated by technology, keeping backups throughout the process means you can experiment and learn without the fear of failure. If at any point you don't get the results you expect, then just make a fresh copy from your backup and try again. I'll remind you many times throughout the following chapters to make fresh backups at key steps in the workflow.

Throughout this project you'll be spending a lot of time on the computer, so before we go any further, let's review the tools and technology I recommend for organizing your photos.

Computer

This might seem obvious, but a computer is the first essential tool for organizing photos of all kinds. Lots of people today use smartphones and tablets for many of their technology needs, but these aren't up to the task of big photo organization projects. I use my iPhone every day to take lots of snapshots, but when it's time to convert, curate, and organize photos, I use a computer exclusively. The main benefits of a computer compared to a phone or tablet are a larger display, greater storage capacity, and better software options that you'll need to work efficiently.

If you're organizing photos for yourself, you can use either a macOS or Windows computer, according to your preference. However, if you plan to organize photos for other people, a macOS system will enable you to do things that simply aren't possible with Windows. For example, many Apple device users have their digital photos stored in the proprietary Apple Photos/iCloud platform, and it's easier to access and extract that content with a macOS computer.

Regardless of what computer platform you choose, there are three factors that make a big difference on a project like this:

- **Large Display:** Organizing photos is inherently a visual activity, so working on a small screen or tiny laptop is very limiting. I prefer a display in the 24–27-inch range because I can see multiple photos or multiple windows at once as I'm copying files and comparing images. You might think that if bigger is better, then why not jump up to a larger display in the 30–34-inch range if your budget allows? Before you make that decision, I encourage you to sit in front of one of these larger monitors for a few minutes and work in all corners of the screen. I've always found that these monitors are too large to view comfortably, which causes me to move the display farther away, which means the effective viewing size is about 27 inches in the end. Buying a 27-inch display in the first place will probably save you money and improve your ergonomics.

- **Plenty of RAM:** I recommend at least 16GB of RAM in a computer that will be used for large photo organizing projects. The amount of RAM matters because increased memory allows you to run multiple apps simultaneously and work on multiple photos at once. If you have a big project and a big budget, increasing RAM to 32GB can increase the performance of demanding apps such as Adobe Lightroom Classic and Adobe Photoshop, but anything over 32GB is probably overkill.

FIGURE 3.1 I find that displays in the 24–27-inch range really increase my productivity, but displays that are 30 inches and over feel unwieldy. Test your options before you buy anything new.

- **Lots of External Storage:** As you consider the ideal computer configuration for organizing your photos, you can't overlook the need for lots of hard drive storage. Almost all of our client projects use less than 1TB of storage, but there have been a few in the 1–2TB range and some as large as 8–10TB. When you choose a hard drive, you'll want to consider these factors:
 - You need enough storage space for all the digital photos you'll gather in the next chapter, but don't forget that you're probably going to delete a lot of duplicate files. Our average client project has about 50% duplicate files. That said, you may have lots of photos to scan, and you'll keep taking new photos, so plan for the future and give your collection room to grow.
 - There are currently two types of hard drives available: conventional spinning hard drives and solid-state drives (SSDs). SSDs are much faster and more durable, but also a lot more expensive. Your choice will depend on your storage needs, your budget, and your patience.

- The most common connectors used for external hard drives these days are USB and Thunderbolt. Both of these are great options and are available on both macOS and Windows computers. USB-C and Thunderbolt use the same connector type, but the Thunderbolt option will be a bit more expensive and offers faster transfer speeds. In the last twenty years, the tech industry has evolved from SCSI, eSATA, and FireWire cables to USB and Thunderbolt, so don't be surprised if in the next ten to twenty years you need to refresh your hard drive storage to new kinds of drives with different cables and connectors.

- Did you notice that I specified lots of *external* storage? Technically speaking, there's nothing wrong with storing all your digital photos on your internal hard drive, if they fit. However, two trends in computing are making this more challenging. The first is that many computers are being designed in smaller form factors with smaller SSD hard drives. The second trend is that more people are using multiple computers, such as a work and a home machine, or a desktop and a laptop. In light of these factors, keeping all your photos on the internal hard drives of all your computers can be expensive and cumbersome. Therefore, consider storing your Family Photo Archive on an external hard drive because it's faster, more convenient, more economical, and easier to backup.

Organizing Software

We use Adobe Lightroom Classic for all our photo organizing clients at Chaos to Memories, and we recommend it for any project. It's a very popular application that includes photo organization, image editing, and creative sharing features all in one. Here are ten reasons why Lightroom Classic is our top choice:

1. **Professional Tool:** Lightroom Classic is trusted by millions of photographers around the world, and if it's good enough for the pros, then it's good enough for you and me.

2. **Cross-Platform:** I prefer Macs, but it's a cross-platform world and Lightroom Classic is available for both macOS and Windows.

3. **Trusted Vendor:** There have been a lot of photo organizing apps and services that have come and gone in the last twenty years, but Adobe is a multi-billion dollar company that's been in business since 1982 and is a cornerstone of the photography industry.

4. **Supports Industry Standards:** Adobe has created some of the most important industry standard file formats, such as TIFF and DNG, and XMP (Extensible Metadata Platform) for metadata, and Lightroom Classic is rated as fully compliant by the IPTC standards organization.

FIGURE 3.2 Adobe Lightroom Classic is the only app I trust for photo organizing projects.

5. **Supports Many Formats:** Lightroom Classic supports a variety of digital formats including JPEG from point-and-shoot digital cameras, TIFF from scans and old digital cameras, HEIC from modern smartphones, hundreds of camera raw formats from professional digital cameras, and many common video formats.

6. **Analog and Digital:** Lightroom Classic was originally developed to streamline digital photography workflows, but because it supports so many file formats, it's the ideal app for working with digital and scanned photos. You can even use it to manage digitized videotapes and film reels.

7. **Plays Well with Others:** I organize photos with Lightroom Classic, but sometimes I use other apps such as Adobe Photoshop for digital restoration or Adobe Premiere Pro for video editing. I appreciate that Lightroom Classic integrates seamlessly with other apps to make these workflows easy and efficient.

8. **Frequent Updates:** A subscription to Lightroom Classic includes frequent speed improvements, feature enhancements, and support for new cameras.

9. **Extensibility:** While I love Lightroom Classic and rely on it every day, it's not perfect and doesn't do everything I need. That's why I appreciate its extensibility, which allows third-party developers to create plug-ins that add special features, improve workflows, and sync with online services. Throughout the book, I'll recommend some of my favorite Lightroom plug-ins that will accelerate your photo organizing workflow.

10. **Performance:** We all have lots of photos, and we're taking more every year. That's why I appreciate the speed of Lightroom, even on catalogs with millions of photos!

Deduplication Software

The other software you'll need for this project is a good deduplication app. There are lots of options, and I've tested more than I can remember, so these recommendations reflect countless hours and literally millions of deleted duplicates. I'll show you how I approach deduplication in chapter 5, but for now, these are my recommendations for your digital toolkit.

- **Overall Favorite:** My favorite deduplication app is dupeGuru (**dupeguru.voltaicideas.net**), because it's fast, free, and cross-platform. It's not as visual as some other options, but I actually like that because I can do so much so quickly.

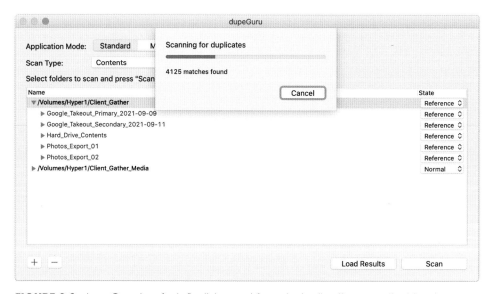

FIGURE 3.3 dupeGuru is a fast, flexible, and free deduplication app that I use on every project.

- **Lightroom Plug-In:** Duplicate Finder (**www.bungenstock.de/teekesselchen**), a plug-in for Adobe Lightroom Classic, is another great option that's fast, free, and cross-platform. It's full of customizable options, and I like that it runs inside the app where I'm already doing the rest of my organization.

FIGURE 3.4
This Duplicate Finder plug-in for Adobe Lightroom Classic has many options that can be used in different combinations for fine-tuned cleanups.

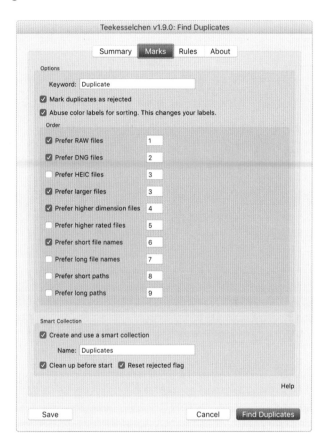

- **macOS App:** PhotoSweeper (**overmacs.com**) is a popular macOS-only app that's very effective. It has viewing options that let you compare duplicates, and it works well with Lightroom Classic catalogs.
- **Windows App:** Duplicate Cleaner Pro (**duplicatecleaner.com**) is a top Windows-only app with lots of customization options and extensive file-format support for both photos and video.

Backup Software

When mountain climbers ascend a peak, they clip their ropes into new anchors higher and higher on the mountain. They take this safety precaution so that if they lose their grip, they fall only a few feet instead of tragically to their death. Backups function the same way: Even if you make a mistake, you won't suffer catastrophic loss.

With reliable hard drives, good backup software, and a little discipline, you don't have to worry about losing any photos or work. I recommend making a fresh backup every time you do photo organizing work you wouldn't want to lose. For example:

1. Gathered your digital files? Make a fresh backup!

2. Converted some files? Make a fresh backup!

3. Curated your best photos? Make a fresh backup!

The backup software I recommend is:

SuperDuper for macOS
shirt-pocket.com/SuperDuper

Acronis Cyber Protect for Windows
acronis.com/en-us/products/true-image

After you assemble your toolkit, the first phase of the workflow is gathering your photos. Are you ready to start phase one? The sequence matters and there's no skipping ahead, so let's start gathering in the next chapter.

PHASE 1:
Gather

Every photo organizing project starts with gathering. This helps you to estimate the scope of the project, save time, and minimize redundant work. For example, if you gather all your digital files and deduplicate up front, then you don't have to waste time organizing the same files twice. With physical photos, if there are negatives and prints of the same image, then you need to scan it only once if you gather everything up front. A thorough and efficient gathering phase is the cornerstone of every successful photo organizing project.

4

Gathering Digital Photos

When I start working with a new photo organizing client, one of the first things I must do is convince them to stop apologizing. They apologize for being disorganized, for not knowing where everything is, and for taking so many photographs. I tell them that I've seen everything and that nothing surprises me. I really mean that when I say it, and my sincerity starts to put clients at ease.

After we exit the apologizing phase, we can start in earnest on the gathering phase. And one of the biggest challenges of organizing digital photographs is that they typically span about twenty years, which means they come from multiple cameras, computers, and hard drives, stacks of CDs and DVDs, untold memory cards and thumb drives, and many file formats. I've even had clients tell me that one old laptop is dedicated to their first child's photos, the Windows machine is the home of the photos of their second child, and the MacBook Air has whatever photos they happened to take of their third child.

This is completely normal, but the fact that digital photos, countless duplicates, and incomplete backups are distributed across so many devices makes this a challenging phase of the project. This digital chaos makes it difficult to even estimate the scope of the project. I used to ask new clients approximately how many digital photos they had, but they either didn't know how to answer, or their estimates were wildly off. After a while I realized it was a question that people just couldn't answer until we completed the gathering phase, and I stopped asking.

Every project starts with digital chaos, and the solution is a digital gathering process with two primary goals: thoroughness and efficiency.

You want to be thorough because you don't want to miss any important memories. At the same time, you need to be efficient so that this phase doesn't take forever. Don't forget that you still have four more phases in the workflow after gathering, so you can't afford to get bogged down here.

Mindset

Before we get into the mechanics of digital gathering, let's talk about a mindset that will help you to be successful. It might sound a little heartless, but it helps to be dispassionate about your photos while you're gathering them. The problem is that if you pore over every photo, relive every memory, and retell every story, then you'll never make any progress.

You'll encounter photos that bring back wonderful memories of important life moments, family vacations, and college shenanigans. Other times you'll discover photos that remind you of loss and disappointment. Try not to get lost in your photos, but stay focused on the gathering process. There will be time later to enjoy and share your memories and it will be a great experience, but you can't afford to do it right now!

Gathering Sources

The first step is to gather all the different sources of your digital photos. You might need some storage bins or to commandeer the dining room table, but gathering everything together in one place is the essential first step.

Typical sources of digital photos include:

- Computers (gather the power cords and passwords, too)
- External and backup hard drives
- CDs and DVDs
- Memory cards (don't forget to look inside old digital cameras)
- USB thumb drives
- Online services such as iCloud Photos, Amazon Photos, Google Photos, and others (make sure you know your usernames and passwords)

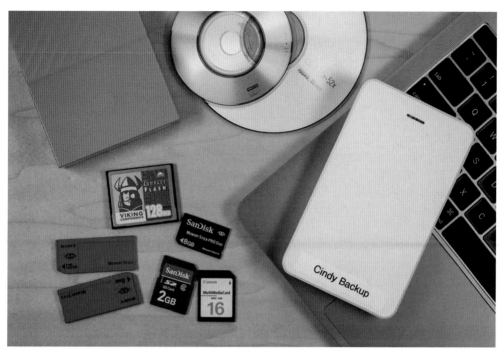

FIGURE 4.1 Gather everything that holds your digital photos in one place, including computers, hard drives, smartphones, tablets, optical discs, memory cards, and thumb drives.

Required Tools

Meanwhile, you must assemble what I call your Digital Gathering Toolkit. This includes a hard drive to store all the files you're copying, as well as the cables, cords, and adapters you'll need to access digital files from all the devices you've gathered.

At a minimum you'll need the following tools:

External Hard Drive: I recommend an external hard drive with a USB 3 or Thunderbolt connector and at least 1TB of storage. If you're a professional photographer or prolific amateur, you might need a higher-capacity hard drive, but 1TB has been enough storage for almost every Family Photo Archive I've worked on. It's also convenient if the hard drive is bus-powered, which means it gets all the power it needs from the computer it's attached to instead of requiring an external power adapter.

When you choose an external hard drive, you'll have to decide between conventional spinning hard drives, which operate at much slower speeds and cost less, or newer solid-state drives, which are much faster and much more expensive. As you decide what sort of hard drive you prefer and what fits your budget, let me suggest that you buy at least two of the same drive so that you have a working drive and a backup drive from the very beginning. There's really no sense in doing all this work if you aren't implementing backup best practices from the very beginning.

WARNING The steps below teach you how to format a hard drive, which erases all data on the drive. If you're formatting a hard drive that's been used before, be sure to make a copy of any important files before you follow theses steps.

If you're working exclusively with Apple devices, use the Disk Utility app to erase and prepare your hard drive for the gathering process. If you're using a spinning hard drive, choose the Mac OS Extended (Journaled) format. For SSDs, choose the APFS format. You'll notice several options that are case-sensitive or encrypted, but you should skip them because they add unnecessary technical complexity to your setup.

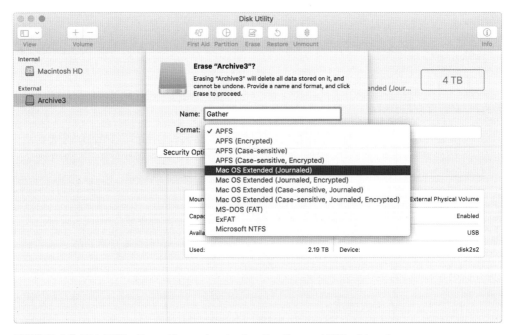

FIGURE 4.2 Disk Utility (found by going to Applications > Utilities) is a free app preinstalled on every Mac that you can use to format new hard drives.

If you're working with a Windows computer, then connect your external hard drive, right-click the drive icon, and choose the Format command. Choose the NTFS (Default) file system, give the drive a name in the "Volume label" field, and click Start. If you're working with a combination of macOS and Windows computers, format your hard drive with the exFAT file system, which allows you to read and write to the same hard drive from both platforms.

FIGURE 4.3

Format hard drives for Windows with the NTFS file system.

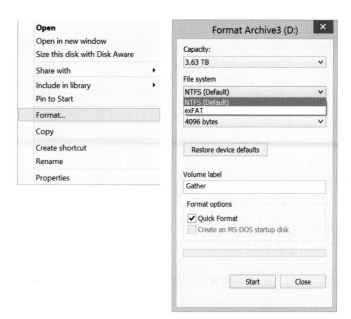

Computer: You'll also need a computer to work with as you gather all your digital files. It doesn't matter if it's a macOS or Windows system, and it doesn't even have to be a new or fast computer because most of what you're doing in this phase is just copying files. One feature I do find helpful is a larger display. You'll be working with so many files, folders, and windows that you'll want enough screen real estate to keep track of everything easily.

Multicard Reader: If you have memory cards, such as CompactFlash, SD cards, memory sticks, and so on, then you'll need a multicard reader to copy files from all those different card formats. Some of my favorite card readers are from SanDisk and Lexar, but there are lots of great options. Just make sure the card reader supports USB 3 for fast copy speeds.

Optical Drive: Most people have a stack of CDs and DVDs that were used to back up digital photos, but many modern computers don't have a built-in optical drive that can read these discs. If that's you, then make sure you have an external optical drive. These work reliably on macOS and Windows computers and can be purchased inexpensively. If you have miniCDs or miniDVDs (8cm in diameter instead of 12cm), I suggest you purchase an optical drive with a tray that slides in and out instead of the slot-loading kind, which can't handle the smaller discs.

Cables: You'll also need the appropriate cables to connect your various hard drives, gadgets, and adapters to your computer. The most common types are USB cables for hard drives and data cables for your smartphones and tablets. Because I like to be prepared for anything, I also keep less common cables on hand, including different formats of USB and FireWire cables just in case. Exactly what you need will depend on the kinds of devices you own. If you can't find the cables you need in your home or office, then virtually any replacement can be purchased online.

Stickers: The last tool I suggest is incredibly helpful but very low-tech. Purchase a set of small, colored stickers, and use these to mark each device after you copy your digital photos from it. This is a simple and effective way to keep track of what has been copied and what still needs to be done. The gathering phase can be a lengthy process, so you don't want to waste any time copying the same files twice.

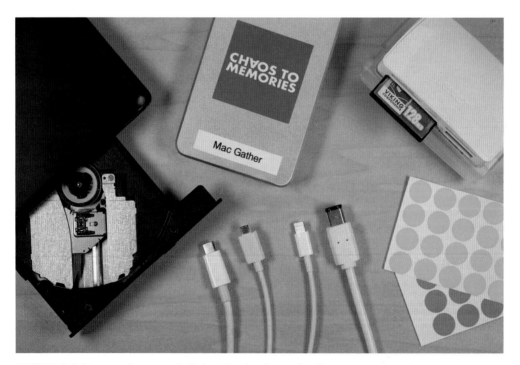

FIGURE 4.4 Prepare for your digital gathering by collecting your computer, external hard drive, and all the cables and adapters you need for your devices and digital storage formats.

What Are You Looking For?

You probably have a good sense of the files you need to gather, but don't forget that technology has changed a lot during the first twenty-plus years of digital photography. The most common digital photo format is JPEG, which uses the .jpg or .jpeg file extension, but depending on the cameras you've used, there might be other formats you need to gather, including:

 HEIC/HEIF (High Efficiency Image Container/File Format): This is a more modern digital photo format that records higher quality in smaller file sizes when compared with the JPEG format. Apple adopted this format in 2017 with the release of iOS 11, so you will likely have lots of HEIC files from recent years if you use an iPhone or iPad.

 TIFF (Tagged Image File Format): This is a common format for scanned photos and some early digital cameras. It's been around since the 1980s, but it's still a good format that can retain excellent image quality.

 PNG (Portable Network Graphic): Many computers and phones store screenshots in this format. You'll have to decide if these screenshots are worth keeping, but it's a common digital image format you might discover.

 CRW/CR2/CR3 (Canon Raw/Canon Raw 2/Canon Raw 3): Canon digital cameras store their high-end camera raw image captures in these formats, which will be familiar to many professional and serious amateur photographers. If you don't use Canon cameras or don't use the camera raw format, then you shouldn't expect to have any of these files in your archives.

 NEF (Nikon Electronic Format): Nikon digital cameras store their camera raw image captures in this format.

 ARW (Sony Alpha Raw): Sony digital cameras store their camera raw image captures in this format.

 DNG (Digital Negative): This format, created by Adobe back in 2004, is an open standard for camera raw images. Many serious photographers convert their proprietary camera raw files (CRW, CR2, CR3, NEF, ARW, etc.) to this standard.

Some of the most common formats for digital video include:

MP4 (Motion Picture Experts Group-4 Part 14): The most universal digital video format captured by many digital cameras, phones, and tablets is also used by popular video services such as YouTube and Netflix.

3GP (Third Generation Partnership Project): This is a low-quality video format used by some early smartphones.

MOV (QuickTime Movie): This is a common digital video format captured by many digital cameras, iPhones, and iPads. This format works on macOS and Windows, but it is more common on Apple devices because it was developed by Apple.

AVI (Audio Video Interleave): Some early digital cameras captured digital video with this format. This format works on macOS and Windows, but it is more common on Windows computers because it was developed by Microsoft.

Gathering from Devices

After you've gathered all your source devices, your empty new hard drive, and all the cables and adapters you need, then it's time to start copying your digital files into one central location. It's important in this phase to focus just on copying. You might think about deduplicating or curating your files at this point, but resist that temptation. You'll certainly copy some duplicates, but in the overall workflow, I've always found it more efficient to copy everything and deduplicate later.

Start by attaching your external hard drive to your computer with the appropriate cable. An icon for your drive should show up on the desktop of your Mac; on a Windows computer, you can browse to your hard drive with File Explorer. Instead of copying all the loose files to the hard drive, it's helpful to create new subfolders for each device and source so you can keep track of where the files came from.

There are often clues on the source media, such as labels on memory cards and notes on CD cases, that provide helpful context. Use these clues to create and name destination subfolders for each memory card, disc, hard drive, and device you copy files from. Subfolders with descriptive names also streamline the deduplication process that you'll learn in the next chapter.

For each device, drag files directly to your destination subfolders in Finder (macOS) or File Explorer (Windows) to copy them to your gathering hard drive. Systematically copy one device at a time to ensure nothing is overlooked.

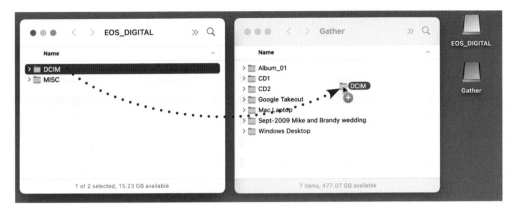

FIGURE 4.5 Creating a destination subfolder for each source retains useful clues and prevents the gathering process from creating a jumbled mess.

The time it will take you to complete this phase depends on how many files you have, how many sources you're copying from, and the speed of your devices. With some client projects, I can complete a full digital gathering in just one to two hours. For my largest projects, it's taken a week or more to copy very large amounts of data from multiple computers, hard drives, and NAS (Network Attached Storage, such as Synology and QNAP) devices. Your project will probably be somewhere between those two extremes.

Considering all this file copying can take a while, I've developed a process to complete this phase as efficiently as possible. The idea is to start copying the largest sources first so that you can copy from smaller sources at the same time for maximum efficiency. For example, I always start with computers and hard drives with the most data. These copies can take hours or even days, but in the meantime, I can copy files from other smaller and faster sources.

The next devices I gather from are smartphones and tablets. If you're gathering from an iPhone or iPad, I suggest using iMazing (**imazing.com**). This powerful app runs on macOS and Windows, and it allows you to download photos from various apps on your Apple devices to your hard drive. If you're gathering photos from an Android phone or tablet, you can connect the device to your computer with the appropriate USB cable, mount the device as a USB storage volume, and copy digital photos and videos directly to your gathering hard drive.

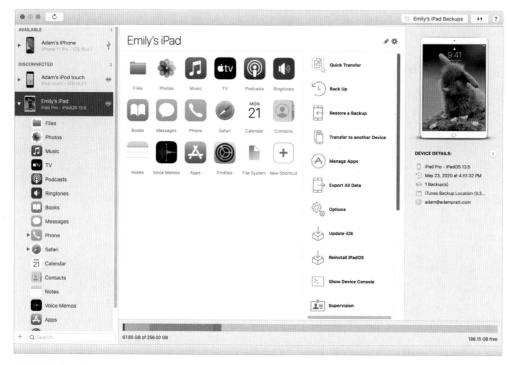

FIGURE 4.6 iMazing is a powerful app that runs on macOS and Windows and makes it easy to gather digital photos and videos from your iOS devices.

My next step is to gather digital files from CDs and DVDs. These don't store that much data, but they're relatively slow to copy because of how the data is stored on the discs. Generally speaking, a CD can hold about 700MB and a DVD can hold about 4.5GB.

After the optical discs, I move on to smaller and faster devices, including memory cards and USB thumb drives. This is an especially important time to use the small, colored stickers to mark each device after you've copied digital photos from it, so that you don't lose track of what has been completed and what still needs to be copied.

To recap, the copy sequence I use for maximum efficiency is:

1. Computers and hard drives

2. Smartphones and tablets

3. CDs and DVDs

4. Memory cards and thumb drives

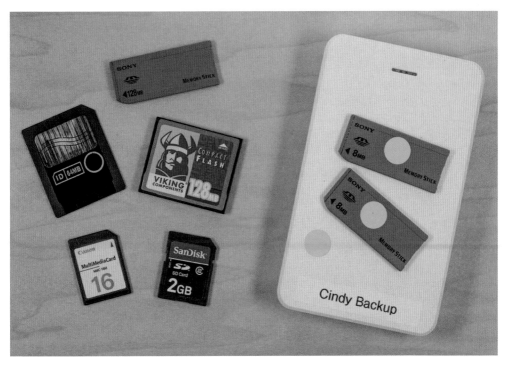

FIGURE 4.7 Use colored stickers to keep track of what's been gathered and what still needs to be copied.

As you gather digital files from all these sources, here are a few tips to help make the process thorough and efficient:

- The most common places to find digital photos on your computer are your Pictures, Downloads, Documents, and Desktop folders.

- When you copy files, make sure you include the enclosing folder, not just the images. For example, a folder name such as "Sept-2009 Mike and Brandy wedding" gives you important context that you'll use later in the organizing phase. Losing these details would be a real shame, so make sure to retain folder names and other digital clues.

- It can also help to keep track of the source locations from which you copy files. At the end of the gathering phase, I'll suggest that you delete all the files from their original sources so you don't end up with disorganized, redundant files. Applying a color tag in Finder (macOS) is an easy way to find your sources again later in the project. For example, you can apply a red tag to all the folders you gather, which makes them easier to find and delete later. Unfortunately, File Explorer (Windows) doesn't offer the same convenient labeling system, but you can also keep track of source locations in a simple text file.

FIGURE 4.8
Use colored tags to keep track of all the places you've gathered digital photos from so it's easier to delete them at the end of this phase.

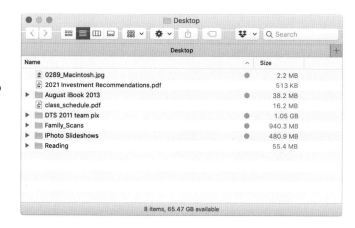

Gathering from Cloud Services

After you gather from your physical devices, the next step is gathering from the cloud services and websites that aren't in your physical possession. Some services make it relatively easy to extract your digital photos, but others treat your photos like hostages. Following are some tips for gathering your photos from some of the most popular cloud services.

GOOGLE PHOTOS

This popular cloud service offers one of the easiest data export processes with the Google Takeout option. Visit **takeout.google.com**, log in with your Google username and password, and deselect all options except for Google Photos. You can download all your photos batched into zip files as large as 50GB each, so make sure you have enough free space on your hard drive to download and unzip the exported files.

FIGURE 4.9
Use the Google Takeout service to gather your digital photos and videos from Google Photos.

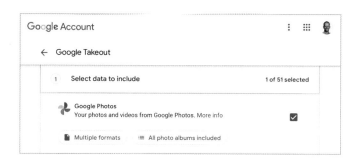

After you unzip the exported photos, you might notice two things:

1. If you have so many photos that Google Takeout packages them in multiple zip files, you'll find that the images might not be organized logically. For example, you might have photos from the same year in multiple zip files instead of being consolidated together. It doesn't seem very logical, but it won't matter with the workflow you're learning.

2. For every image that's exported, there's a corresponding text file with the .json file extension. These JSON files are tiny bits of text that contain details such as capture date, capture time, and GPS coordinates that are already embedded in your digital images. These files usually aren't very useful, so I do a quick search in Finder (macOS) or File Explorer (Windows) for files ending in .json, and delete them en masse. This way I'm left with just the digital photos and videos that I care about and not all those settings files.

3. If you happen to have added lots of image descriptions that you want to keep in the metadata of your images, then keep the zip files you download from Google Takeout and run them through the Metadata Fixer app from **metadatafixer.com**. It's an inexpensive app that copies the descriptions entered in Google photos and embeds them into your digital photos.

FIGURE 4.10

The Google Takeout process is easy, but leaves a mess like this. My standard process is to delete all the .json files so I can focus on organizing the photos and videos.

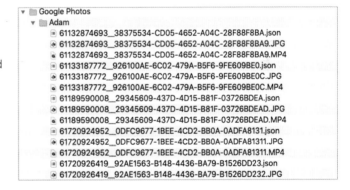

AMAZON PHOTOS

Amazon Photos is another popular cloud service, especially for people already enjoying an Amazon Prime membership. Gathering all your digital photos from the Amazon website isn't possible, but if you visit **photos.amazon.com** and download the Amazon Photos desktop app for your computer, it's a cinch. Just launch the app, log in, and download all your photos. The download might take a while and you might need lots of hard drive space, but it's easy with the Amazon Photos desktop app.

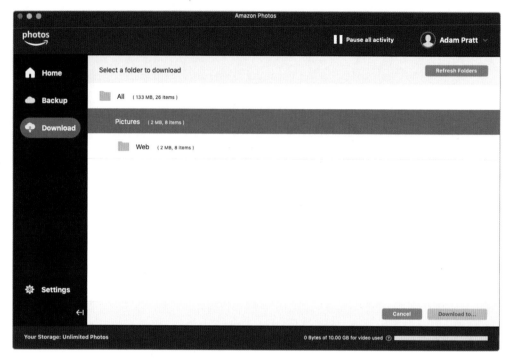

FIGURE 4.11 The Amazon Photos desktop app makes it easy to download all your photos from Amazon's popular cloud photo service.

iCLOUD PHOTOS

iCloud Photos is one of the most popular cloud photo services, but it's also one of the most difficult platforms to gather your photos from. On your Mac, launch Photos, open the application preferences, and switch to the iCloud tab. If iCloud Photos is disabled, then all your photos are already on your hard drive. However, if iCloud Photos is enabled and the Optimize Mac Storage option is selected, then you probably have low-resolution versions of many of your photos on your computer, and the full-resolution versions reside on iCloud. Because the goal is to always retain the best possible quality, you'll need to download the higher resolution versions to your computer. Before you do, you'll need to make sure you have enough space. You can estimate how much you need by opening System Preferences, and choosing iCloud. Once you know the files will fit, go back to the iCloud tab of the Photos application preferences and choose the Download Originals to this Mac option. The files will then start to download (sync) from iCloud.

The sync can take hours or days, depending on how many photos you have in iCloud and the speed of your internet connection, but connecting to Ethernet instead of Wi-Fi can definitely speed things up.

FIGURE 4.12 Open the iCloud settings on your Mac (under System Preferences) or your iPhone (in the Settings app) to estimate how much space all your full-resolution photos will require.

FIGURE 4.13
The first step to gather high-resolution images from iCloud Photos is to enable the Download Originals to this Mac option in the application preferences.

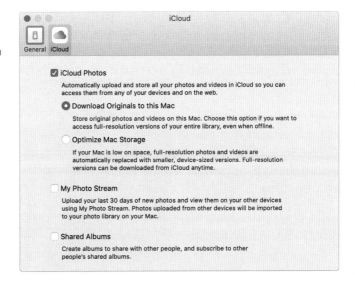

After the sync is complete, I use an app called PhotosTakeout (**photostakeout.com**) to extract all the original images from the Photos Library to my hard drive. You can also select File > Export > Export Unmodified Originals from the Photos menu bar, but the PhotosTakeout method has the advantage of retaining the keywords you applied to your photos in the Photos ecosystem.

FIGURE 4.14 I like to use the PhotosTakeout app to extract all the high-resolution photos from a Photos Library, because it retains metadata such as keywords.

In an ironic twist, the fastest and easiest way to extract original photos from an iCloud Photos Library might be to use a Windows computer and the CopyTrans Cloudly app (**copytrans.net**/**copytranscloudly**). This inexpensive Windows app installs on your computer, logs in to your iCloud account, and downloads all your photos into organized subfolders.

FIGURE 4.15
CopyTrans Cloudly makes it easy to download high-resolution images from the Apple iCloud platform, but this app is available for Windows only.

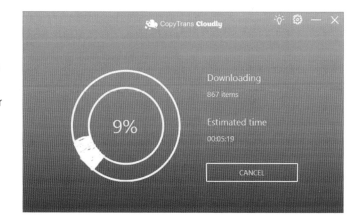

SHUTTERFLY

One photo website that is popular with crafters but unpopular with photo organizers is Shutterfly. Extracting photos from this service isn't difficult, but it's very tedious because Shutterfly limits you to downloading 500 photos at a time.

FIGURE 4.16
Shutterfly limits you to downloading 500 images at a time.

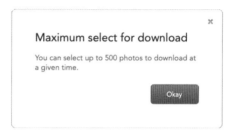

Even worse, each batch of 500 photos is distributed across multiple zip files. This means that downloading a large photo collection from Shutterfly might require downloading several hundred zip files that need to be unzipped and merged. If you're lucky, you'll have these photos backed up somewhere else and you won't have to go through this tedious process.

FIGURE 4.17
If you must gather photos from Shutterfly, go through the process systematically so you don't miss anything.

Inventory

After you've copied and downloaded everything, I suggest completing a basic inventory of the project. You can use the Get Info command (macOS) or the Properties command (Windows) to calculate the total storage size of everything you've gathered. This isn't necessary, but I think it's interesting to see where these projects start and where they end. How much hard drive space will you save? How many duds and dupes will you purge? Capture the before state, and you can compare it with your final results at the end of the organizing phase of the workflow.

Backups

You probably realize how important a good backup strategy is for a photo organizing project. When you have a Family Photo Archive that's sorted, searchable, and shareable, you need to keep it safe with a good backup plan. But you should also be making backups as you go through this workflow. If you've done hours of work gathering all your images, it would be a real shame to lose that progress if there was a technical failure or a human mistake. Therefore, I strongly recommend that you start practicing the discipline of good backups, even now in the gathering phase.

Make sure your backup drive is formatted with the same file system (Mac OS Extended (Journaled), APFS, NTFS (Default), or exFat) as your gathering drive, and name the two drives something obvious likes Photos 1 and Photos 2. Now, copy all your gathered files from Photos 1 to Photos 2. You just gathered all your digital photos in one place and completed your first backup. Doesn't that feel great?

FIGURE 4.18

After you gather everything, take note of the number of files and size of storage for a dramatic before/after comparison at the end of the project.

For extra protection, you should consider making a second backup on a third hard drive that you store off-site. An alternative to an off-site hard drive backup is a cloud backup service, such as Backblaze (get one month free at **bit.ly/3Jh3x7k**). In fact, I use both an off-site hard drive backup and a Backblaze account. It might sound like overkill, but I've never lost a computer file!

PHOTOS 1
Primary

PHOTOS 2
Backup

PHOTOS 3
Offsite

FIGURE 4.19 An easy way to remember backup best practices is 3-2-1: three copies, two different hard drives, one off-site copy.

For subsequent backups, you can save lots of time by backing up only what's changed instead of the entire digital archive. For incremental backups, I recommend SuperDuper! (macOS) and Acronis Cyber Protect (Windows). Instead of you copying the entire archive every time or manually keeping track of what's changed, these software apps keep track of what's changed and copy only the necessary files for an exact backup. Instead of backing up for hours, these incremental backups are usually completed in minutes.

Delete Originals

The last step of the gathering phase is to delete the originals from their original source locations after everything has been gathered in one place and backed up. This is an important step because it helps guard your privacy on old computers, and it also limits the digital chaos of having too many copies of your photos in too many places.

I'll emphasize the importance of a consistent workflow throughout this book, and this step of deleting original source files is the perfect example of why a repeatable workflow is so important. You want to gather everything together, then copy it to one place, then make a backup *before* you delete the original images from their source media.

Notice how deleting the originals is the last step in this phase? You want to do that only *after* you make a backup. Why? Suppose you gathered and copied everything into one hard drive, deleted the originals—and then that drive died. Without a backup, you'd be in a terrible situation! If you're still not quite ready to delete your digital files from their original storage locations, then you'll find detailed instructions for doing so in the last chapter.

Congratulations for making it to this milestone. Even if you stopped reading now, at least you'd have all your digital photos gathered in one place, along with a current backup. Your photos aren't organized and searchable yet, but at least they're safe!

5

Deduplicating Photos

After you gathered all your digital files back in chapter 4, you might have felt overwhelmed. Our average client project starts with more than 100,000 digital files, and some clients have millions of photos to organize. The good news is that a typical project includes more than fifty percent duplicates. And I'm not talking about similar photos, but exact technical duplicates. If you delete these duplicates, it's going to simplify your project, save time, and bring you relief. After all, there's no sense in organizing what you're just going to throw away, right?

When I teach people about the deduplication process, I often use an analogy about house-cleaning. I ask, "What's the easiest thing to clean?" The thing you throw away. That's also true of digital photos. If you delete the duplicates from your archive early in your workflow, it benefits you in so many ways, including the following:

- Faster to select your favorites (a.k.a. curation, see chapter 11)
- Faster to organize what's left (metadata, filenames, etc., see chapter 12)
- Requires less hard drive space
- Enables faster backups
- Less overwhelming for loved ones who inherit your photos

Sources of Duplicates

Understanding the source of digital duplicates enables you to deduplicate efficiently and thoroughly, and helps you minimize this hassle in the future. These are the seven most frequent causes of duplicates we see in our client projects at Chaos to Memories:

- **Redundant Backups:** We see redundant backups on hard drives, DVDs, CDs, and other devices. The worst example was a client who had fifty-seven backups of the same set of images. Having multiple backups is a good thing, but too many backups become a liability and just add to the confusion and digital clutter.

- **Incomplete Upgrades:** Over the years, you might have upgraded from one app to another, such as when Apple replaced iPhoto with Photos. If you didn't delete the original library after a successful migration, your files might be taking up tons of hard drive space and making the photo organization process more complicated.

- **Unformatted Memory Cards:** When we perform a digital gathering session for a new client, we often find the same photos on their hard drive and on their unformatted memory cards from their digital cameras. In the future, you should format your memory card immediately after your photos are imported to your photo archive and backed up.

- **Creative Projects:** Even if you have a well-organized photo archive, many people save derivative photos for creative projects, such as photo books, slideshows, and other craft projects. It's a great idea to work on copies of your photos for these creative projects, but when the project is over, consider deleting the derivative versions so you don't add to your digital clutter. If you keep the best-quality, highest-resolution originals of your favorite photos, you can always create another derivative copy for another creative project in the future.

- **Family Sharing:** Families love to share their photos with each other through a variety of methods, including email, texts, and wireless transfers via Apple's AirDrop. The downside of this sharing is that you often wind up with the same photos on many devices and sometimes multiple copies on the same phone or tablet. Sharing is fun, but it can lead to lots of duplicates.

- **Social Media:** People love to share their photos on social media, but those derivative files add to the digital chaos and decrease their quality. For example, Facebook compresses your photos, Instagram reduces the resolution, and WhatsApp strips the capture date. If you use these social media apps, make sure you keep your original photos and let the internet enjoy your low-resolution shares.

- **Screenshots:** You'd be shocked by how many photos we find on people's phones that are just screenshots of other photos. These low-resolution duplicates add to your clutter and don't retain the high quality that you want to keep in your Family Photo Archive.

Now that you understand common ways that duplicates happen, you can be on guard to minimize the digital chaos in the future. Remember, the goal is to have one master copy at the original quality and resolution, with reliable backups.

Kinds of Duplicates

Before you start deduplicating your gathered photos, let's review the different kinds of duplicates you'll be identifying and deleting. Note that each kind of duplicate requires different criteria when you decide which version to keep and which one to delete.

- **Exact duplicates:** These files are identical in every way, including file format, capture date, file size, pixel dimensions, and filename. In this case, you should keep one and delete the others. There's not much of a decision to make here because they're exactly the same in every discernable way.

- **Same except for filename:** Sometimes you'll have two files that are identical in every way except the filename. I'm sure you've seen filenames like IMG_1579 copy.jpg on your computers. In this situation, you can delete either one because the content is the same, but I prefer to keep the file with the shorter, original filename, such as IMG_1579.jpg.

- **Same except for file format:** If you use a good digital camera and shoot in the camera raw format, you might have matching pairs of images where one is the raw format (CR2, CR3, NEF, ARW, etc.) and one is a matching JPEG file. In these situations, I typically keep the camera raw file and delete the JPEG. The logic here is that I can always export a new JPEG from a camera raw file, but I can't turn a JPEG back into a camera raw file and recapture the original quality. The only exception to this would be if you used the JPEG file from this pair to do creative edits or digital retouching work in an app such as Adobe Photoshop. In that case, I suggest keeping both the camera raw file, so you have the original capture, and the JPEG, TIFF, or PSD file, so you don't lose any creative work you've done to your images.

- **Same except for date:** If you discover a pair of files that seem identical in every way except for the capture date, then I suggest keeping the file with the earlier capture date. The file with the earlier date is likely the original capture, and the file with the later date is probably a copy or derivative in some way.

- **Same except for pixel dimensions:** When you have a duplicate pair of images and the only obvious difference is pixel dimensions (a.k.a. image resolution), keep the file with the higher pixel dimensions. The image with higher pixel dimensions is likely the original capture, and the lower resolution file is probably a lower-quality copy or derivative of some sort. If you edit, save, crop, or share an image, the resolution often gets reduced and almost never increases. Bigger is almost always better when deduplicating digital photos.

Consider a common example from social media. Imagine you have a smartphone with a 12-megapixel camera that captures images at 4,000 x 3,000 pixels. If you post an image of that size to Instagram, it's cropped, downsampled, and compressed to 1,080 x 1,080 pixels. Your image will shrink from 12 megapixels to 1 megapixel, which is a reduction of more than ninety percent in image data. If you care about the quality of your images, you definitely want to keep the original, uncropped, uncompressed, full-resolution photo. Remember, you can always make a new low-resolution version with a filter if you keep the original capture, but you can't upgrade that low-resolution image back to its original resolution, quality, and color.

- **Same except for file size:** This is similar to the last example with pixel dimensions, but not necessarily the same thing. Reducing the pixel dimensions of a file almost always reduces the storage size of a digital file, but a file can also be made smaller through aggressive compression. You always want the original, high-quality image, so in this situation keep the image with the larger file size and delete the smaller file.

- **Burst mode:** Did you know that the most specific time that digital cameras can store a photo is to the closest second? This becomes an issue if you use burst mode on an iPhone at 10FPS (frames per second) or a GoPro that captures 30FPS. If you run deduplication software on a burst of images like this, the app might think that all those images were shot at the same time and all but one should be deleted. But while they were shot very close together—in one second or less—they aren't identical photos. You might want to keep the entire burst to relive the moment or use them in a fun creative project. Or you might want to keep just one photo that captures the highlight or finale of the action. However you approach it, this is a question of curation, which you'll learn about in chapter 11. For now, be careful about accidentally deleting bursts of images with your deduplication software so you can curate them thoughtfully later.

FIGURE 5.1 This burst of four photos was captured in the same second, but the images aren't exact duplicates. With a burst like this, you might want to keep your favorite or all four.

When to Deduplicate

When you deduplicate your photos is as important as *how* you complete this step in the workflow. When I'm deduplicating large client projects, it's common to delete tens of thousands of files in a single pass, and with so many memories on the line, it would be tragic to make a mistake in this phase without a fresh backup. Therefore, you should gather your digital files and back them up before you deduplicate your archive.

The other reason the sequence of workflow steps matters is that you want to deduplicate *before* you do any detailed organizing. You don't want to waste time adding keywords, writing captions, and renaming files that you're just going to delete through deduplication. A good workflow is a series of repeatable steps that you always do the same way in the same sequence, and this is an excellent example of why the sequence of your workflow matters.

How to Deduplicate

As I mentioned earlier, dupeGuru (**dupeguru.voltaicideas.net**) has become my favorite stand-alone deduplication app. After testing countless options, I've found that I can deduplicate the most photos, most accurately, in the least amount of time with this app. It's not a very visual app, but if you don't require visual entertainment, this app is a workhorse. My process starts with broad criteria and moves to more specific criteria:

1. Make a fresh backup of all the digital files your gathered files, just in case you make a mistake. Review chapter 4 if you need a reminder on backup best practices, and keep this backup until you're confident in the results of your deduplication process. If you have any doubts or make a mistake, just revert to the backup of your gathered files and try again. With good backups, you can keep experimenting and learning until you get the hang of it, but without any consequences.

2. Open dupeGuru, choose a folder of images that you think is the most complete and reliable source, add it to the folder list in dupeGuru, and set the State of the folder to Reference. This means no photos can be deleted from this folder or its subfolders, and other photos will be compared against this reference folder. For example, if most of your photos are gathered from the Pictures directory of your computer, set that as your Reference folder so all the images you gathered from other sources will be deduplicated against this folder.

3. Add other gathered folders of images that you want to deduplicate to dupGuru, and set the State of each to Normal.

4. The goal is to delete as many duplicates as possible in a short amount of time, so I start with the broadest parameters and proceed to more specific criteria in subsequent passes. For the first pass, I select the Folders option from the Scan Type menu, which determines if there are any folders with the same files in them. Instead

of taking a lot of time to compare file versus file, this Folders option can identify and delete bigger chunks of duplicates in less time.

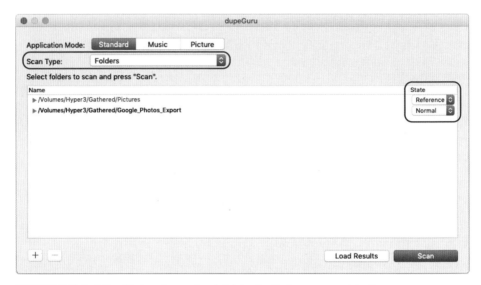

FIGURE 5.2 Set the State of your best folder to Reference, add other source folders with the Normal State, and run your first scan with a Scan Type of Folders.

5. Every time you run a scan, you'll see a dupeGuru Results window with a list of the folders and files that match your scan criteria. Folders and files that are suspected duplicates are indented and listed in black, while folders and files to be kept are listed in blue. To mark folders for deletion, you can put a check mark next to each folder in the results window, or choose Edit > Mark All if you're satisfied with the results. After you've marked the duplicates, choose Actions > Send Marked to Trash to delete them. Close the scan results window, and get ready to run another scan.

Filename	Size (KB)	Match %
20100101_airport	34913	100
20100101_airport	34913	100
20100102_stockholm	23330	100
20100102_stockholm	23330	100
20100104_stockholm	159159	100
20100104_stockholm	159159	100
20100105_volvo	126909	100
20100105_volvo	126909	100
20100106_gothenburg	173750	100
20100106_gothenburg	173750	100

FIGURE 5.3 The higher the value in the Match % column, the more confident dupeGuru is that those folders and files are exact matches.

6. For the second pass, I change Scan Type to Contents, which starts by looking for files with identical file sizes, and then compares other technical aspects of the files. This is slower than the Folders option, but is still relatively efficient at finding lots of duplicates.

FIGURE 5.4
The speed of a duplicate scan depends on the number of files and the speed of your computer, but it's the most efficient way to identify thousands of duplicates.

Scanning for duplicates

11056 matches found

Cancel

Before I decide what to delete, I look in the dupeGuru Results window at the different columns such as Match %, Modification date, and Size. You can also customize what information is shown in the Results window by clicking the Columns menu in the menu bar.

To visually compare two files, I click the Preview icon (👁) and switch back and forth between the suspected duplicates. My habit is to compare a few at the top of the list, then scroll down to the bottom and check a few others that might have a lower Match %, and evaluate the results.

If I'm happy with the results, I use the Mark All or Mark Selected commands, and then run the Actions > Send Marked to Trash command. If the results aren't duplicates, I close the Results window and try again with different files or different settings.

	Mark All	⌘A
	Mark None	⇧⌘A
	Invert Marking	⌥⌘A
	Mark Selected	^⌘A

dupeGuru Results

Details Dupes Only Delta 👁

Filename	Folder	Size (KB)	Modification			
IMG_1100.MOV	/Volumes/Hyper3,	Photos_Ex...	3926	2021/08/3	Cut	⌘X
✓ IMG_1100.MOV	/Volumes/Hyper3,	Photos_Ex...	3926	2021/08/3	Copy	⌘C
IMG_3484.JPG	/Volumes/Hyper3,	Photos_Ex...	2404	2021/08/3	Paste	⌘V
✓ IMG_3484.JPG	/Volumes/Hyper3,	Photos_Ex...	2404	2021/08/3		
IMG_8849.JPG	/Volumes/Hyper3,	Photos_Ex...	3044	2021/08/3		
✓ IMG_8849.JPG	/Volumes/Hyper3,	Photos_Ex...	3044	2021/08/3	Filter Results...	⌥⌘F
IMG_3404.JPG	/Volumes/Hyper3,	Photos_Ex...	2660	2021/08/3		
✓ IMG_3404.JPG	/Volumes/Hyper3,	Photos_Ex...	2660	2021/08/3	Start Dictation...	
IMG_7550.JPG	/Volumes/Hyper3,	Photos_Ex...	2148	2021/08/3	Emoji & Symbols	^⌘Space
✓ IMG_7550.JPG	/Volumes/Hyper3,	Photos_Ex...	2148	2021/08/30 20:...	100	---
IMG_6078.HEIC	/Volumes/Hyper3,	Photos_Ex...	1508	2021/08/30 18:...	100	1
✓ IMG_6078.HEIC	/Volumes/Hyper3,	Photos_Ex...	1508	2021/08/30 18:...	100	---
IMG_1695.HEIC	/Volumes/Hyper3,	Photos_Ex...	1636	2021/08/30 17:...	100	1
✓ IMG_1695.HEIC	/Volumes/Hyper3,	Photos_Ex...	1636	2021/08/30 17:...	100	---
IMG_2926.JPG	/Volumes/Hyper3,	Photos_Ex...	2404	2021/08/30 19:...	100	1
✓ IMG_2926.JPG	/Volumes/Hyper3,	Photos_Ex...	2404	2021/08/30 19:...	100	---
IMG_2893.JPG	/Volumes/Hyper3,	Photos_Ex...	4452	2021/08/30 19:...	100	1

FIGURE 5.5 Review the results and compare some duplicate pairs to ensure you're discarding the correct files.

Note: The third option in the Scan Type menu is Filenames, but I usually skip this because it often returns as many false matches as accurate duplicates. It's common for there to be multiple IMG_0001.jpg files in a large collection, but the files could have nothing else in common beyond their name. When deduplicating digital photos, I usually need more specific criteria than just filenames.

7. For Application Mode, click Picture, and then set Scan Type to EXIF Timestamp, which uses the EXIF capture time in the image metadata as the comparison criteria. This might or might not work, depending how your images have been edited, and you should be cautious about using it on bursts of photos. It normally runs quickly, because it's a relatively simple scan to perform, so I always give it a try and delete any duplicates found.

FIGURE 5.6 Run another scan with Application Mode set to Picture and Scan Type set to EXIF Timestamp to deduplicate your remaining photos based on their capture time. (You'll notice there is also an Application Mode dedicated to Music, but I never use this because I'm focused on digital photos.)

8. For the remaining photos, I stay in Picture mode but set Scan Type to Contents. This performs a computer-driven visual analysis of every image against every other image, and it can yield very helpful results, especially on scanned images or digital images with different resolutions. The downside of this search is that it can be very slow. Therefore, this is always the last duplicate scan I run, so that the most demanding comparison runs on the smallest number of images. For context, the algorithm behind this scan is systematic and thorough, comparing every image against every other image. This means that if you run this scan on 10,000 images, dupeGuru will do 100 million (10,000 x 10,000) visual comparisons for you!

9. Before I'm done, I change the state of my most trusted folder from Reference to Normal. This means that dupeGuru can now deduplicate within this set of files, and I run through steps 3–8 again on the entire collection. After I go through this second round of scans, I'm typically getting few to no new matches, and I'm confident I've done a good job of deduplicating the digital files I've gathered.

The results of this process might not be perfect, but you can accomplish an incredible amount of comparing and deduplicating in a short amount of time, all without looking at many photos. It's important for you, and your clients if you organize photos for other people, to understand that the results of deduplication probably won't be perfect. I joke that "perfect costs a million dollars, but we can do amazing for a lot less." Even after all these recursive scans, there might be some remaining duplicates, but I don't feel the need to apologize to our clients for this. I just delete any stray dupes as I find them and remind the client how much we cleaned up so quickly.

> **TIP** Deduplicating large collections of digital files can be an intimidating process at first. You might feel overwhelmed by the number of files or be afraid to accidentally delete precious memories. In addition to good backups, another way to overcome the fear factor is to deduplicate in smaller batches instead of doing the entire collection at once. This will be easier and more manageable until you build your confidence with the deduplication process.

Alternative Apps

dupeGuru is my preferred deduplication app, but you should be able to follow a similar process with other apps, such as PhotoSweeper (macOS) and Duplicate Cleaner Pro (Windows). Another deduplication solution that works well on its own or in conjunction with other apps is the Duplicate Finder plug-in for Lightroom Classic, which you can download for free from **bungenstock.de/teekesselchen**.

After you've imported photos into a Lightroom catalog (see chapter 6), you can run this free plug-in, which includes lots of useful options. For example, you can use the Rules panel to customize which technical attributes are used to determine which files are duplicates. One of the best things about this Lightroom plug-in is that instead of deleting the photos immediately, it adds a temporary keyword and sets them aside in a collection of duplicates. This means you have a very visual way to review the results of the scan, clear incorrect matches, and be in complete control of what gets deleted.

FIGURE 5.7
Even after using dupeGuru
before I import photos
to Lightroom, the free
Duplicate Finder plug-in
provides a helpful second
pass to remove duplicates.

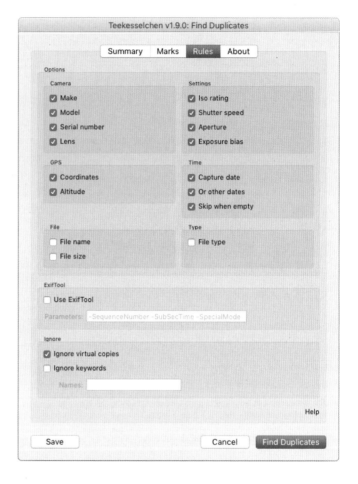

Final Steps

Thorough deduplication will require multiple passes, and it's another important milestone in the process of decluttering your photo life. Before ending this chapter, let me suggest two more important steps:

1. Make another inventory of your remaining files, including storage size and file count. Comparing these numbers with the inventory you completed in chapter 4 on all your gathered files will give you a sense of how many duplicates you've purged and how many remaining photos need to be curated (chapter 11) and organized (chapter 12). This before-and-after comparison is an impressive reminder of the progress you've made.

2. When you're comfortable with the results of your deduplication, you should make a fresh backup of your remaining photos before you proceed to the next step in the workflow.

6

Creating Your Photo Archive

Organizing decades of photos is a time-consuming project, but a good photo organizing workflow will save you lots of hassle, dead ends, and rework. Knowing where to start is overwhelming for most people, but we use the same organizational system for every Chaos to Memories client, and it's going to work for you too.

Before I teach you the next steps, let's review the shortcomings of other organizational systems you might have already tried. The three most common options that seem like a good idea at first are to organize by person, event, or subject. Here's why you'll regret each one of them...

By Person: The most common system we see people try is organizing photos by person. The motivation behind this is to untangle a collection of photos so that different family members can each have "their" photos. Unfortunately, this system doesn't hold up very long.

As soon as you have a photograph with more than one person in it, the system breaks. For example, if you have a family portrait with three children, whose folder or pile should that photo go in? You might be tempted to make duplicate copies of that photo, but that defeats the purpose of trying to simplify your photo collection.

Organizing photos by person also assumes that people only want to see photographs of themselves. Most people aren't that narcissistic, but enjoy seeing photos of themselves with friends and family they love. Sorting by person is the plan most people start with,

but it's probably the worst possible system because it unnaturally separates photos that belong together. A major reason people organize photos is to connect with others, but organizing photos by person actually breaks the sense of story and connection.

By Event: The next organizational system that we see many people attempt is by event. For example, they might put all the Christmas photos in one group, birthday photos in another group, and summer vacation photos in a third group. The problem with this approach is that having decades of Christmas photos all smooshed together gets overwhelming, and the specialness of each year is lost. Trying to discern one year from another after a recurring event is merged is very difficult. Other events such as summer vacations are even more difficult to tell apart when photographs of beaches, mountains, and sunsets start to blur together and lose their context.

By Subject: The third common organizational system we see people try is by subject. In this case, someone might organize their photos into groups of car photos, dog photos, sunset photos, and so on. This seems like a good idea at first, but it falls apart when you realize you have lots of photos that don't fit into your major categories. This system usually results in a few workable categories and a huge miscellaneous pile. Unless you're a scientist cataloging species of plants or insects, avoid organizing your photos by subject.

What Works?

So what photo organization system does work? We use a three-step system that's never let us down:

1. **Sort photos chronologically:** This is relatively easy and is an essential first step that doesn't take much time (this chapter).

2. **Add searchable metadata:** This is the most time-consuming, but valuable, step in the system (see chapter 12).

3. **Rename files:** This is the least important step, but it's easy to do and makes for nice presentation (see chapter 12, page 146).

This three-step system is simple, relies on open standards, and works every time. It works for my photos, millions of our clients' photos, any kind of camera, and any kind of computer, and it's going to work for you, too.

Chronological organization is the cornerstone of my system because it works for every archive, everybody understands dates and times, and it doesn't require any explanation. Dorothea Lange, a remarkable American photojournalist, said, "Photography takes an instant out of time, altering life by holding it still." Because photographs capture a moment in time, it makes sense to organize them by time. Digital cameras and smartphones automatically record the date and time in every photo, which means your computer can organize your digital photos for you!

Sorting chronologically might sound rigid, but in practice, it's quite flexible. If you're not one hundred percent certain when a photo was taken, you can always use approximate dates, and you'll still be able to sort and search the photos sensibly. If you have scanned photos that are hard to date, there are ways to handle that, which I'll address in chapter 13 (page 153). A chronological system is also flexible because you can always add new photos you discover without disrupting the photos that have already been organized by date.

Sorting by Date

Not only is sorting photos chronologically the most logical and flexible method, it's also the easiest to implement because good software can do it for you. Sorting large digital photo archives manually would be almost impossible. The good news is that because most digital photos have accurate capture dates embedded in the files, you can use Adobe Lightroom Classic to automatically sort digital photos chronologically based on their digital capture dates.

Alternative Apps

I use Lightroom Classic for my entire photo organizing workflow, but if you're looking for an alternative app to complete the chronological sorting into subfolders, then check out:

- Big Mean Folder Machine (macOS; **publicspace.net/BigMeanFolderMachine**)
- PhotoMove (Windows; **mjbpix.com**)

It's up to you how specifically you want to sort your photos: by day, month, or year. Obvious factors include how many photos you have and how detailed you want to be with your Family Photo Archive. It's easier to combine a bunch of subfolders than it is to separate files into multiple subfolders, so I always have Lightroom sort digital photos by the day they were taken, and then I group them more generally if it makes sense for the project.

I start each photo organizing project with a new Lightroom catalog and follow these four steps every time:

1. Create a new Lightroom catalog (File > New Catalog) in a location with enough space for all the photos in the project, such as an external hard drive. If you're not sure how much space you need, then revisit the results from chapter 5 and note the file size of all the images you gathered minus the duplicates you deleted. Give your new catalog an obvious name, such as Family Photo Archive.

2. Next, create a new folder called Photo Archive, and save it next to your Lightroom cat-
 alog file. This is important for two reasons: All the photos you import into this catalog
 will be stored in this parent folder, and this parent folder is stored in the same place as
 the Lightroom catalog, which makes it easy to back up the catalog and photos at once.

FIGURE 6.1
Click the plus icon in the
Lightroom Folders panel
to add a new folder,
name it Photo Archive,
and save it in the same
place as your Family Photo
Archive.lrcat file.

3. Open the catalog settings (Lightroom Classic > Catalog Settings on macOS, or Edit >
 Catalog Settings on Windows), click on the Metadata tab, and enable the "Automatically
 write changes into XMP" setting. This ensures all the metadata you're going to apply later
 is automatically saved into your images instead of only in the Lightroom catalog.

FIGURE 6.2 Customize the catalog settings so all metadata is
automatically embedded in your files.

4. Finally, as an optional touch, you can customize the identity plate so that the name of the project is clearly displayed at the top of the Lightroom window. If you're organizing your own photos only, this might not matter to you, but if you work on multiple projects or organize photos for other people, then this obvious label can minimize confusion as you switch between Lightroom catalogs. Choose Lightroom Classic > Identity Plate Setup (macOS), or Edit > Identity Plate Setup (Windows) on Windows, set Identity Plate to Personalized, and type the name of your project.

FIGURE 6.3 Customizing the identity plate is optional, but it is especially helpful if you work with multiple Lightroom catalogs.

Importing Digital Photos

After you've created and configured your Lightroom catalog, it's time to import your digital photos into a chronologically sorted folder structure. Follow these steps:

1. With your empty catalog open in Lightroom, click Import in the bottom left of the Library module.

FIGURE 6.4 Click Import in the bottom-left corner of the Library module to start the process of organizing your digital photos by date.

2. On the left side of the Import dialog, select the source of the files you're going to import. This should be the digital files remaining after the deduplication process you completed in chapter 5.

FIGURE 6.5

Select the Source folder of the images you want to import on the left side of the Import dialog, and enable the Include Subfolders option.

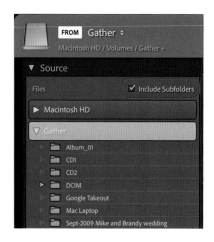

3. At the top of the Import dialog, click on the Copy option, and preview the thumbnails in the middle of your screen to confirm that you've selected the right files. If you choose Add, it will just leave your photos in the same location and folder structure. This isn't what you want for digital photos, but it's a great option if you have scanned photos that are already organized into subfolders. The Move option moves the files from the original location into the folder you designate, but if the process doesn't work as expected or you make a mistake, it's a pain to untangle this for a second attempt. Therefore, I recommend using the Copy option. This should deliver the results you expect, but if something doesn't work, you can just delete the copied files and try again.

FIGURE 6.6

Choose the Copy option at the top of the Import dialog.

4. On the right, specify a few important settings:

 - **File Handling:** Most duplicates should be removed at this point, but it won't hurt to enable the Don't Import Suspected Duplicates setting.

 - **File Renaming:** Don't rename photos at this point, as that's something you'll do later in the workflow.

 - **Destination:** Choose "Organize: By date" and select the date format you prefer. I like the YYYY/YYYY-MM-DD option because it organizes the files chronologically, but with only one level of subfolders.

 - **Destination:** Set your Destination folder as the Photo Archive folder you created earlier in this chapter. This is a very important setting because it tells Lightroom where to copy your digital photos when it sorts them by date.

5. When you're ready, click Import in the bottom-right corner of the dialog, and Lightroom will begin its magic. You might have to wait a while for the process to complete, so if you're working on a laptop, make sure it's plugged in and you don't run out of power in the middle of the import.

The workflow steps you've learned in this chapter are the backbone of how I organize digital photos for myself and my clients. If you're also organizing prints, slides, negatives, and albums, then you'll want to read the next chapter about gathering physical photos.

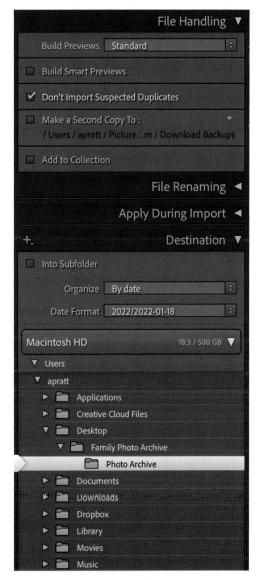

FIGURE 6.7 Set your Photo Archive folder as your destination folder and tell Lightroom to organize your digital photos by date using your preferred date format.

7

Gathering Physical Photos

Most people made the transition to digital photography in the early 2000s, after amassing a collection of analog photography in the form of photographic prints, albums, negatives, and slides—all of which might be in your family photo collection, too. If you want to include these physical photos in your Family Photo Archive, then you'll need to complete a separate gathering process.

Just like with organizing digital photos, gathering together your physical photos in one place helps you understand the scope of your collection and the formats you're dealing with. Many clients tell me they have a shoebox of photos, and it actually turns out to be several large bins. One client claimed to have a few small boxes, and I ended up loading dozens of boxes into a van. Most people have more physical photos than they realize, so set aside a large, solid surface, such as a desk or dining room table, to gather them. Steer clear of the kitchen, as there's too much traffic, water, and food to be safe.

As you gather your physical photos, make sure to follow these best practices:

1. **Clues:** Keep the original envelopes, receipts, and other ephemera for clues about dates and locations where the photos were taken.

2. **Negatives:** Don't separate negatives from their corresponding prints. Many people tell me they've discarded their "useless" negatives, but negatives are almost always the best source to scan. Separating prints from negatives makes the organization much harder, so keep them together.

3. **Double prints:** Double prints were cheap and popular back in the 1980s and 1990s. Don't worry about discarding double prints now. There will be a time later when you can choose to discard or share the doubles.

4. **Removal:** If you remove photos from albums, scrapbooks, or picture frames, make sure to label them if you plan to return them. For example, you can put a Post-it Note with the number #1 on the back of a portrait and on the picture frame with which you want to reunite it after you've scanned the print.

Find

Most of us have filled our homes with photos of all kinds and they're distributed in so many places. People often say that gathering their family photos would be one of their highest priorities if their house was on fire, but as you work on this gathering phase, you'll realize how unrealistic it is to do this quickly. It usually takes my clients a few hours to get everything in one place. Here is a list of the most common places you'll find physical photos:

Obvious Places

Photo albums

Wedding albums

Framed pictures

Scrapbooks

Slide carousels

Storage

Shoeboxes

Storage boxes

Basement

Attic

Garage

Crawlspace

Around the House

On the refrigerator

Drawers

Dressers

Closets

Under beds

Nightstands

Jewelry boxes

Wallets

File folders

Bookmarks

Bibles

People

Parents

Siblings

Grandparents

Aunts, uncles, cousins

Guardians and foster parents

Don't Forget

Bank/safety deposit box

Home safe

Undeveloped film

Handle with Care

As you start to gather your physical photos, here are a few things you may encounter and some pro tips to handle them carefully:

- **Wear gloves:** The stereotype is white cotton inspection gloves like in the movies, but those aren't my favorite because they can be slippery, making it hard to keep hold of

negatives. Instead, I like nitrile gloves because they're thin and offer good grip. The other benefit of nitrile gloves is that they don't include latex rubber, which makes them a viable option for people with a latex allergy.

FIGURE 7.1
I recommend nitrile gloves for grip, dexterity, and comfort.

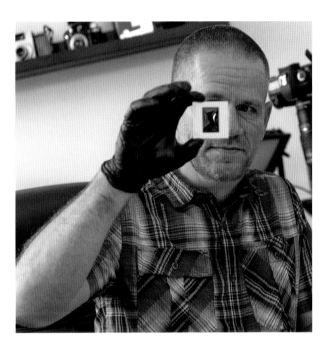

- **Adhesive albums:** If you have photos in the old-fashioned albums with sticky pages and plastic protectors, you'll probably want to remove them to slow down any further discoloration and deterioration. These are often called "magnetic" albums, but there's nothing magnetic about them. Magnets would be welcome, but instead, these use an adhesive that's hard to remove and not good for photographs. Sometimes the adhesive in these albums has dried and the photos can be removed easily, but if your albums are still sticky, use a craft spatula and dental floss to separate the photos from the pages. Just make sure to keep the photos in sequence and store them in a labeled envelope. This helps retain their dates, sequence, and story.

- **Slide carousels:** If you have slides in carousels or other holders, you should leave them there until you scan them. Slides were often loaded in the order they were taken, or in a way that tells the best story, so you don't want to lose that sequence and context.

- **Scrapbooks:** If you have black scrapbooks, which were popular in the early 1900s, especially with photos glued to the pages, I suggest leaving them in place. Removing photos from these pages can cause more damage than leaving them in place. With the right scanning equipment, scrapbooks can be scanned as complete pages, individual photos, or both.

- **Picture frames:** If your picture frames are old, dirty, or otherwise in need of refreshing, then removing the prints makes them easier to scan. Removing prints from frames is usually a simple process, but if the frame doesn't have a matte and the print is stuck to the glass, then leave it in the frame until you can scan it or take it to a professional. Even if you plan to keep the pictures in the frames, this project might be a good opportunity to clean the glass and remove the prints for scanning. Just make sure to take a snapshot or make a list of which photos go with which frames so you can return them where they belong when you're done.

- **Curled and rolled photos:** In the early 1900s, it was popular to make large panoramic photos of school classes, military groups, and social clubs. These are fascinating prints, but due to their unwieldy size, they were often stored in a tight roll. If a print stays curled like that for decades, it will require careful handling so it can be unrolled, flattened, and scanned without damaging the original. If you discover a rolled or tightly curled photo print like this, work with a professional who can gradually humidify the print, flatten it, and create an archival scan without tearing the paper or cracking the emulsion.

- **Glass plate negatives:** Glass plate negatives are a rare photo format from the mid-1800s to the early 1900s. If you discover any of these in your collection, they can be scanned by a professional, but should be handled with special care. Specifically, don't stack them like pancakes or they can break or scratch each other. Don't wear cotton or nylon gloves because they're too slippery when handling the glass plates, and don't hold the plates by their corners, which are most likely to break or chip. Instead, wear nitrile gloves, hold the plates by both long edges, and store them vertically along their long edge. For the best protection, store them in four-flap paper envelopes in a sturdy cardboard box, and use filler paper so they don't fall over and break. Finally, it's a good idea to label the box clearly with heavy and fragile warnings so people aren't surprised by the weight and don't handle them carelessly.

FIGURE 7.2

Glass plate negatives offer an incredible window into the past but are very fragile and must be handled with care. Always hold a glass plate with two hands on the long edges.

- **Mold:** Mold usually doesn't smell musty, but it can cause permanent damage to your photos and be dangerous to your health. Mold damage can be slowed, but not reversed. Your best option is to wear protective gear (gloves, mask, and goggles) while you seal the photos in a plastic bag and freeze them until they can be scanned or cleaned by an expert.

- **Vinegar syndrome:** If you discover photographic negatives or film reels that smell like vinegar, this is an obvious indication that the film is suffering from a common form of decay called vinegar syndrome. You can slow down the decay by storing the film at cold temperatures, but you can't reverse the damage. If you're unable to move the film to cold storage, make sure you digitize the reels as quickly as possible, and then store them in breathable storage. Airtight storage might seem like a good idea, but it traps the smelly gasses and accelerates the decay.

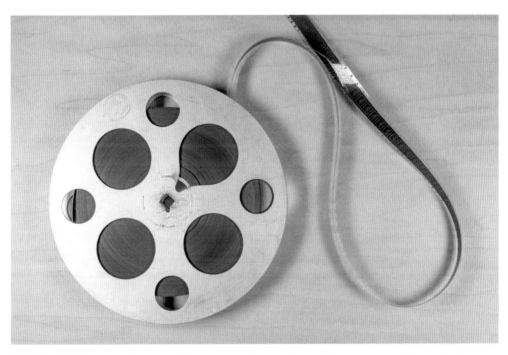

FIGURE 7.3 Film reels that smell like vinegar should be digitized and put into cold storage right away.

· **Marking:** Don't write on photographs, as it can cause damage to the originals. I've seen people write on the front of a photo, which obviously damages the image, with a pencil on the back, which can leave visible impressions, and with ink on the back, which can easily transfer to other photos in the stack. If you need to make notes about an image, then write on the envelope or an index card and use a Stabilo All pencil, which uses a soft, waxy lead.

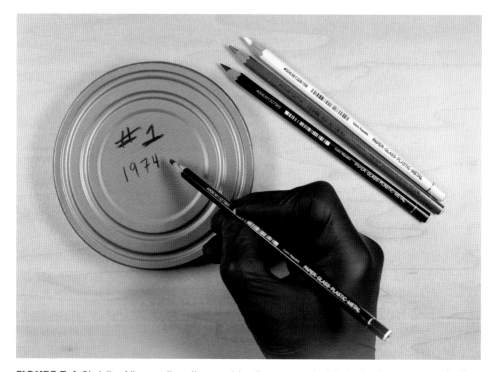

FIGURE 7.4 Stabilo All pencils write on virtually any material, including paper, plastic, metal, and glass. We keep black, red, and white ones on hand in our studio to write on envelopes, plastic negative sleeves, and metal film reels.

Estimate

Counting physical photographs is very time-consuming and is not necessary. In fact, professional photo organizers estimate photos, instead of counting them, using these proven techniques for various formats:

- **Prints:** Printed photographs are about 100 in one stacked inch, which means a shoebox of photos typically holds 800 to 1,000 prints. Photo paper from different time periods will vary slightly, but 100 photos per inch is a helpful estimate.

FIGURE 7.5
Photo prints are about 100 per stacked inch.

- **Slides:** Photographic slides are about 20 per stacked inch. Kodak carousels hold either 80 or 140 slides per carousel. Even if the carousels aren't completely full, these numbers provide an easy way to estimate large collections of slides.

FIGURE 7.6
Slides are about 20 per stacked inch.

- **35mm negatives:** A roll of 35mm film usually has 24 or 36 exposures, so an average of 30 images per roll is an easy way to estimate film collections.

- **Other negatives:** Film came in many different formats through the years, and the average number of exposures per roll varies. A few common film formats include:

 - 126 Instamatic film came on rolls of 10, 20, or 24

 - 110 Instamatic film almost always came on rolls of 24

 - 127 film came on rolls of 8, 12, or 16

 - 120 film (a.k.a. medium format) film typically had 12 or 16 exposures per roll and depended on the camera

 - APS film came in canisters with 25 or 40 exposures per roll

 - Disc film always included 15 exposures per disc

FIGURE 7.7
I use 30 exposures as an average for rolls of 35mm film.

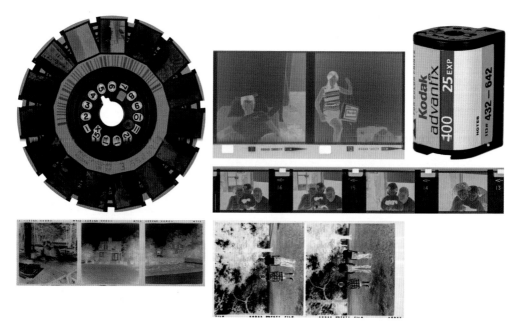

FIGURE 7.8 Various film formats have different averages per roll, but disc film from the 1980s and 1990s always had 15 exposures per disc.

- **Albums:** Photo albums and scrapbooks can be estimated by multiplying the number of pages by the average number of photos per page. Just make sure you're counting both sides of each page.

Store

In chapter 10, you'll learn about scanning physical photos, but you should start thinking now about long-term storage of your original prints, negatives, slides, albums, and scrapbooks. The three main risk factors to guard against are light, heat, and humidity.

The materials you use for long-term archival storage of your physical photos should be:

- **Acid-free:** Make sure to use paper and cardboard whose acidic substances have been removed and with buffering agents added to achieve a pH of 7 or slightly higher.

- **Lignin-free:** This naturally occurring acidic substance in wood pulp should be removed to minimize deterioration, including yellowing, brittleness, and cracking.

- **Good plastics:** To minimize the threat of water damage, including floods, leaks, and humidity, you can store your physical photos in plastic containers made of polyester, polypropylene, or polyethylene. Do not store your physical photos in containers made of polyvinylchloride (PVC) because this unstable plastic gives off gasses that will damage photos.

At Chaos to Memories, we use only archival storage materials for our client projects because we want these precious memories to be safe for as long as possible. Conservation Resources International (**conservationresources.com**), Archival Methods (**archivalmethods.com**), and Print File (**printfile.com**) are a few of our favorite suppliers, and most of what we use are envelopes, negative sleeves, and boxes of various sizes. If you're outside of North America, you might need to find a different regional supplier, but these are the types of materials you're looking for.

In addition to archival storage, the other way to preserve your physical photos for generations to come is to store them in a dark, cool, dry location on the main floor of your home. An interior closet is one of the best storage locations. An easy way to remember this is that your photos should live where people live. In other words, if you wouldn't live in your attic, garage, basement, or crawlspace, then you shouldn't store your photos there either.

Summarize

After you've gathered and estimated all your physical photos, you can create a simple summary of what you have. Here's an example from an actual client project I'm working on as I write this chapter:

Slides in carousels	3,600
Prints in albums	3,000
Loose prints	3,000
Framed prints	30
Oversized prints to uncurl	2
16mm film reels	20 seven-inch reels and 4 three-inch reels
VHS tapes	32

This estimate gives you a better understanding of the scope of your project and the formats you need to digitize. You can also use this estimate to decide if you want to scan your own photos or work with a trusted expert to do it for you. In chapter 10, you'll learn more about different ways to scan photos and make the best decision about how to move forward.

At this point you probably feel a mix of relief because you've completed this gathering project, but are overwhelmed by the mountain of photos you've assembled. This is completely normal, and I want to comfort you with a few reminders:

- **You don't have to scan everything.** You're allowed to throw away double prints, bad images, and photos that aren't important to you. You'll learn all of my curation strategies in chapter 11.

- **You don't have to do it all yourself.** If you have the time, patience, and technical skills, you can scan everything yourself, but you can also outsource all or part of the project to a trusted expert. For example, you might scan your prints but pay to have your slides scanned and film reels digitized.

- **You'll save space.** When a physical photo organizing project is complete, the photos typically fill half the space they did at the beginning. This reduction happens through curation, discarding unnecessary envelopes and paper, and efficiently re-boxing in archival storage.

You're learning a photo organizing workflow that's efficient, consistent, and that gives you the best quality for any format. You've reached the end of the gathering phase and you're ready to learn what's involved in preserving your memories.

Activity: Your Estimate

Use the template below to pencil in the estimates for your photo collection:

Format	Estimate	Notes
Prints in albums		
Loose prints		
Framed prints		
Oversized prints		
Slides		
Negatives		
Videotapes		
8mm film reels		
16mm film reels		

PHASE 2:
Preserve

Preservation is the second step in the workflow and varies based on the kinds of photos you have:

- Digital photos should be converted to industry-standard file formats for long-term preservation.

- Physical photos including prints, negatives, slides, and albums need to be digitized to archival standards.

Now is the time to start implementing backup best practices. You want to enjoy your photos today, but good preservation means they'll be enjoyed for generations to come.

8

Preserving Photos

The second phase of my photo organizing workflow is focused on preservation. You might say I use a wide-angle lens in my definition of preservation, which includes physical photos, digital photos, and even home movies. Different formats require different kinds of preservation, and you'll learn about all of them in the following chapters.

If you're working with digital photos, you'll learn in chapter 9 that digital preservation includes converting to modern formats and ensuring your files are stored in safe places with reliable backups. Physical photos, such as prints, slides, and negatives, should be preserved through scanning, which you'll learn about in chapter 10. Home movies aren't a major focus of this book, but most people have videotapes or old film reels that should also be digitized and preserved.

These examples represent different formats and processes, but they're all important aspects of the preservation phase of my workflow. Preservation is converting formats from the past and preparing them for the future. After working in high tech for more than twenty years, I've learned that technology changes quickly and is full of surprises. We can't predict the future, but we can do our best to prepare for it.

An important aspect of that preparation is recognizing that preservation is an ongoing activity instead of a one-time event. Therefore, be prepared to convert your scanned photos and converted videos to new digital formats and migrate your digital files to new storage devices in the future. I was recently researching a special kind of DVD called M-DISC that claims to last one thousand years. At the same time, I struggled to find a working Iomega Zip drive from just twenty years ago. Even if that claim about M-DISC reliability is accurate, will we still have DVD drives to read these discs in a thousand years?

FIGURE 8.1 This snapshot from a recent project shows four of the most popular digital storage formats of the last thirty years, but today they're obsolete and almost inaccessible. Digital preservation must include file formats and storage media.

Deciding What to Preserve

This chapter is all about preservation, but I want to be clear from the very beginning that the goal isn't to preserve every photo you've ever taken. If we're honest, not all our photos are worth preserving, and instead of keeping everything, the goal is to preserve what's beautiful and memorable. This approach will bring more joy to your collection and requires less work to complete the project. In chapter 11, I'll go into greater depth on my philosophy of curation, but for now let's talk about a general framework for what to preserve:

- **Highest quality:** Organizing photos takes a lot of work, so as you go through this process you'll want to keep the highest-quality original of each photo. If you're a serious photographer, this means keeping your camera raw files instead of converted JPEG files. If you're the family photographer, this means keeping the original high-resolution image instead of low-resolution versions you posted to social media. And if you're preserving physical photos, this means preserving the original film negatives instead of old yellowed prints. Generally speaking, you want to keep a single copy of the original capture in the best condition and highest resolution.

FIGURE 8.2
One of the main goals of digital preservation is to keep the original capture at the highest available resolution and quality.

- **Standard file formats:** A major motivation for organizing and preserving your photos is to enjoy and share them again. Therefore, ensuring your photo memories are in accessible formats is an essential aspect of preserving your photos. With digital photos, this can include converting proprietary camera raw files to the open Digital Negative (DNG) format, which you'll learn more about in the next chapter. For digital videos, it might involve converting less accessible formats, such as AVI, to the more common MP4 digital video format. And when it comes to physical formats, this involves scanning photos and converting videotapes to digital formats. You'll learn more about digital formats in chapter 9, but for now I'll summarize the formats I recommend for digital and scanned photos.

 - **JPEG** (Joint Photographic Experts Group) is the most common format for digital photos and was released in 1992. As long as you use high-quality compression, this is the format we use at Chaos to Memories and recommend for most digital photos.

 - **TIFF** (Tag Image File Format) is another format for digital photos and was released by the Aldus Corporation in 1986 (acquired by Adobe in 1994) as a common format for desktop scanners. TIFF files can have marginally better image quality than JPEGs, but the difference is usually indistinguishable to the human eye and the files are typically ten times larger than the same images in the JPEG format.

 - **DNG** (Digital Negative) is an open standard format introduced by Adobe back in 2004 and supported by many companies in the photo industry. Proprietary camera raw formats can be converted to this industry-standard format to minimize the risk of being locked into just one vendor.

- **Standard metadata:** Metadata is the term for searchable labels, such as names, events, and locations of your photos. These are the technical equivalent of the notes that your grandmother used to write on the back of printed photos. For digital files, the industry best practice as defined by the IPTC (International Press Telecommunications Council) is to embed these searchable tags in your digital files (see chapter 12) so your photos can be searched by any app or cloud service that supports the standards. It's possible to store metadata in a cloud service, a library or catalog, or a separate file, but it's best practice to embed the metadata in your digital files so it's more permanent and travels with the files wherever they go. The practical benefit of implementing industry-standard metadata is that it makes all your digital and scanned photos searchable, which in turn makes them easier to enjoy and share. After all, there's no sense in digitizing and organizing all your photos if you can't find them!

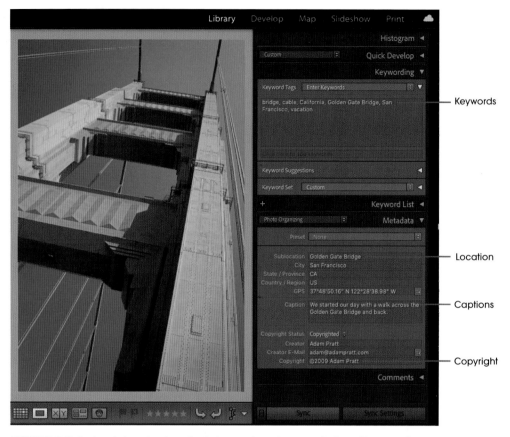

Keywords

Location

Captions

Copyright

FIGURE 8.3 Embed standard metadata, such as keywords, location, and captions, to ensure a file's durability and searchability.

Again, the goal of preservation isn't keeping every photo you've ever taken, but instead preserving your most important photos, at their highest available quality, in formats that are accessible today and future-proof for tomorrow.

Preserving Video and Audio

It's beyond the scope of this book to cover this topic in depth, but I want to acknowledge that you probably have video and audio recordings that are important pieces of your family memory collection. At Chaos to Memories we convert and capture more than twenty different video formats, including video tapes (Betamax, VHS, MiniDV, etc.), lots of film reels (Regular 8, Super 8, 16mm, etc.), discs (DVD, MiniDVD, Blu-ray, etc.), and audio cassettes and reels.

FIGURE 8.4 Audio and video conversion can be an important aspect to many photo organizing projects.

Even though this video and audio content comes from a variety of source formats, we recommend two common digital formats for conversion:

- We convert videotapes and movie film to MP4 digital video files with H.264 video compression and AAC (Advanced Audio Coding) audio compression. This is the same digital video format used by popular video services like Netflix and YouTube, and it is the global standard for digital video. If you know a lot about video, you realize that this is a compressed format and technically is not the very best quality. If you wanted the absolute highest possible quality, you would capture individual uncompressed video frames and uncompressed audio. The tradeoff is that uncompressed video can result in file sizes that are one hundred times larger than a high-quality MP4 file. While uncompressed audio and video are technically the "best quality," this is indistinguishable to the human eye and ear and the file sizes become unmanageable. If you work at a museum or historical archive, then you should consider other formats, but for family memories, the modest file size and universal access of the MP4 format are hard to beat.

- We convert audio recordings including cassettes, microcassettes, vinyl records, and reel-to-reel tape to digital files using the AAC format at a bit rate of 256kbps. Most people are familiar with the popular MP3 file format, but AAC was developed as the successor to MP3 and captures higher quality at the same file size. If you require greater backwards compatibility, then the MP3 format is still a great option.

Whether you convert your own video and audio recordings or work with a trusted expert to preserve them for you, these are the digital formats I recommend for easy access today and tomorrow.

Backups

I'll mention this a few times throughout the book, but it'll never be too many: Make frequent backups. You already learned about backup essentials in chapter 4, so don't forget to make a fresh backup every time you do photo organizing work you wouldn't want to lose.

9

Converting Digital Formats

Most people are concerned about their older physical photos suffering from fading, yellowing, mold, and other kinds of decay. It's obviously important to preserve these memories through archival scanning, but what most people don't realize is that losing their digital photos might be an even greater risk.

If you have a tintype from the 1860s, a print from the 1920s, and a slide from the 1950s, you need only one piece of equipment to view all these formats: the human eye. When it comes to digital photos, there are hundreds of different formats that were developed in just the last twenty years. Many of these formats have already become obsolete and almost impossible to view, so it's important to evaluate your digital archives and ensure your memories can be enjoyed today and accessed in the future.

It's ironic that our generation is taking more photos than ever in the history of the world, but without thoughtful curation and digital preservation, we risk leaving behind a "digital dark age" of inaccessible memories. Vint Cerf, one of the creators of the internet, has raised this issue in recent years, but choosing the right digital formats can help minimize the risk.

When choosing digital file formats to preserve your memories, consider the following five criteria:

- **Accessible today:** It might sound obvious, but is the digital format common enough that you can view, enjoy, and share the files today? There are many formats from recent years that have already become obsolete, and if the format isn't accessible today, it will only be more obscure in the future. If you're dealing with any obsolete formats (page 91), your first step is to convert your files to a modern digital format.

- **Original resolution:** If you convert a digital file to a new format, you want to keep the maximum available resolution of the original. Some of the old digital file formats you have might have come from older scanners or cameras, which means their resolution wasn't very high to start. Therefore, it's important to retain all the image resolution you can access.

FIGURE 9.1 This is the first digital photo I have of my wife and me with our firstborn. It's a dear memory and I can't afford to lose any quality from this 1-megapixel photo from 2001.

If you're not familiar with the importance of image resolution, it records the visual details of an image. High-resolution files give you more details and freedom to use the image in creative projects such as photo books, prints, and high-definition videos and slideshows. A low-resolution image can only be printed at smaller sizes before it shows obvious pixelization.

FIGURE 9.2 The image with higher resolution on the left retains more detail than the low-resolution image on the right.

New technology advancements, such as the Super Resolution feature in Adobe Photoshop and Gigapixel AI from Topaz Labs, perform better upsampling than ever, but your best option is still to retain as much resolution as possible from your original images.

- **Original quality:** Resolution is one aspect of image quality, but other factors such as color space, bit depth, and compression also affect the quality of a digital image. One of the most important factors of image quality is image compression, and there are two types:
 - *Lossless compression* stores digital data more efficiently in smaller files, but doesn't discard any information. Lossless compression is ideal, but the file size reduction is minimal.
 - *Lossy compression* discards some information, but can result in dramatically smaller file sizes. For example, a JPEG file with lossy compression can be 1/10 the size of an uncompressed TIFF file at the same resolution, but if the right settings are used, the human eye won't be able to tell the difference.

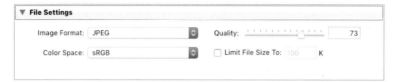

FIGURE 9.3 Saving digital photos in the JPEG format with high quality significantly reduces file size but retains enough visual quality that you won't be able to tell the difference.

- **Appropriate to content:** Various digital file formats aren't good or bad, but they were created for different purposes. For example, the PNG (Portable Network Graphics) format was created as a high-quality, uncompressed format for screenshots and other graphics, but it's a bad choice for digital photographs.

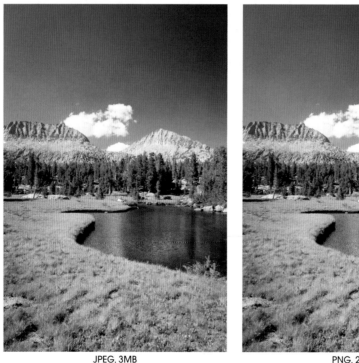

JPEG, 3MB PNG, 21MB

FIGURE 9.4 It's important to choose the best format for the content. The PNG format is great for screenshots, but it's a poor choice for digital photos because it results in much larger file sizes but no improvement in quality.

- **Conversion-ready:** Because technology changes so rapidly, I expect that in my lifetime I'll have to convert my digital images to a new format to ensure their access to future generations. Therefore, I want to choose digital file formats that retain the original resolution and quality, are appropriate to the content, and can be converted again in the future when needed.

Recommendations

I've worked in the tech field for decades and have seen many companies, software apps, and file formats come and go. I can't predict the future, but this is what I'm doing for my Family Photo Archive and for my clients:

- **JPEG** uses lossy compression, which means it discards some information to reduce file size. This lossy compression is customizable with professional software like Adobe Lightroom Classic or Adobe Photoshop, and you can decide if you want higher quality files at larger file sizes, or smaller files with lower quality. The JPEGmini software (**jpegmini.com**) can compress JPEG images at even higher quality than usual, but still reduces the file size.

FIGURE 9.5
JPEGmini offers advanced JPEG compression that can retain high quality at smaller file sizes. You can run JPEGmini as a stand-alone app or as a plug-in with Adobe Lightroom Classic or Adobe Photoshop.

If your digital photos are already in the JPEG format, I suggest leaving them just as they are. They're already in a universal format, can include searchable metadata, and there's no practical benefit to converting them to other formats.

- **Camera raw** is an amazing digital format used by high-end digital cameras to capture very high-quality images. You can think of a camera raw image as the digital equivalent of a film negative. Compared with the common JPEG format, camera raw captures more color and allows for more flexible editing. Unfortunately, there are hundreds

of different camera raw formats from different camera manufacturers and camera models. The multitude of proprietary camera raw formats makes the preservation and conversion of these files a long-term challenge. To address this concern, Adobe released the Digital Negative (DNG) format back in 2004, along with free conversion software and public documentation of the file format. This allows pro photographers, amateurs, and photo organizers alike to convert camera raw files from virtually any company or camera to an open-standard format that has the best chance of being accessible far into the future.

The main benefits of DNG over camera raw files are:

- DNG is a single, open-standard file format supported by multiple vendors instead of relying on a single company.

- DNG uses lossless compression that reduces file size (often by ten to thirty percent, sometimes by up to seventy percent) without discarding any image quality.

- Metadata, such as keywords and captions, can be embedded inside DNG files, which eliminates the need for XMP sidecar files. This reduces your file count by half!

I convert camera raw images from any digital camera to lossless DNG files using Adobe Lightroom Classic. Another option is to download the free Adobe DNG Converter app for macOS and Windows (**helpx.adobe.com/camera-raw/digital-negative.html**)

FIGURE 9.6

Use the free Adobe DNG Converter app to convert proprietary camera raw file formats to the open standard DNG file format.

- The **HEIC/HEIF** (High Efficiency Image Container/High Efficiency Image Format) file format was introduced in 2015 and adopted by Apple in 2017 with the release of iOS 11. It offers higher image quality at smaller file sizes when compared with JPEG images and, in many ways, is an engineering marvel. If you take photos with a recent iPhone or iPad with the default settings, then your images are captured using this new format instead of the more familiar and common JPEG format.

Even after several years in the market, the HEIC/HEIF format has not seen the broad adoption I was hoping for. Many apps and websites still don't support the file format, and Windows users must install special software to view these images.

For now, I suggest converting HEIC/HEIF files to JPEGs with high-quality image compression using Adobe Lightroom Classic or the free iMazing HEIC Converter app (**imazing.com/heic**). This might increase your file size a bit, but you shouldn't notice any loss of visual quality. I'll be thrilled if HEIC/HEIF eventually catches on and becomes a more standard file format outside the Apple ecosystem, but for now I'm prioritizing access over smaller file size.

FIGURE 9.7
Use the free iMazing HEIC Converter app to convert HEIC/HEIF files to the more universal JPEG format.

- The **TIFF** (Tagged Image File Format) file format was released in 1986 by the Aldus Corporation, which was later acquired by Adobe. Even though it's been around for decades, it's still an excellent format for digital photos and is especially popular with many scanners. One common myth about the TIFF format is that it doesn't use image compression. Contrary to popular misconception, TIFF supports two lossless compression technologies (LZW and ZIP) and lossy JPEG compression.

FIGURE 9.8

The TIFF format can use no compression, lossless compression (LZW or ZIP), or lossy compression (JPEG) to save images.

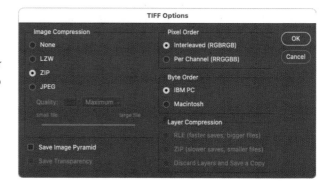

If you have TIFF files and plan to do lots of digital retouching or just want to retain every detail, then I recommend keeping any TIFF files in the TIFF format with ZIP compression. However, if you aren't planning on doing a lot of retouching and like the idea of reducing the file size of TIFF images by about 90%, consider converting scanned TIFF images to JPEGs with high-quality compression. I perform these batch conversions all the time with Adobe Lightroom Classic or Adobe Photoshop, which both offer lots of control over file conversions and compression options.

- **PNG** (Portable Network Graphics) is a digital file format commonly used for screenshots on computers, phones, and tablets. If you follow my suggestions about curation in chapter 11, most of these will be gone. But if you're left with PNG files in your collection, you should know how to handle them.

The PNG format was developed to replace the popular GIF format from the early days of the internet, and for simple graphics and screenshots, the PNG format uses very efficient lossless compression. PNG is a terrible format for photographs, however, and files can easily be five times larger than a high-quality JPEG of the same photo. Whether you keep your PNG files or convert them to JPEGs really depends on the content of the image.

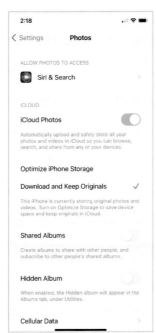

FIGURE 9.9 The PNG format is great for screenshots from phones, tablets, and computers.

- The **Photo CD** (PCD) format was introduced by Kodak in 1992, and for about a decade it was very popular among professional photographers. The Photo CD format included high-quality scans at high resolution, stored on compact disc media. Unfortunately, support for this format faded after about a decade, as Kodak stopped supporting the Photo CD market, never documented the format, and didn't use industry standards for recording the CDs. Sadly, Photo CD is one of the worst examples of a proprietary, abandoned digital format.

If you have images in the Photo CD format, your best option is to rescan the original negatives if they're available. If all you have are the Photo CDs, then one of the only apps that still reads this orphaned file format is the macOS-only GraphicConverter from Lemke Software (**lemkesoft.de/en/products/graphicconverter**). I suggest converting your PCD files to TIFF or JPEG as soon as possible, and don't look back!

- Kodak released the **Picture CD** format in 1998 as a more affordable, consumer version of the Photo CD format. These CDs were just a marketing gimmick for low-resolution JPEGs at 1536 x 1024 pixels per file, which is barely large enough to make a 4 x 6-inch print. Picture CDs were scanned from 35mm and APS film, so if you have the original film or prints, I suggest rescanning them at higher quality. If you don't have access to the original negatives, then you can copy the JPEGs from the CD and cherish your lo-fi memories.

FIGURE 9.10
The Picture CD format from the late 1990s used the popular JPEG format, but at low resolution and quality.

Video Formats

As you work through your digital archives, you'll probably discover digital video files in formats including MOV, AVI, WMV, and 3GP. Some of these formats have been abandoned, others are hard to play on certain computers or devices, and many digital video formats from just twenty years ago face impending obsolescence.

I recommend that you transcode (the technical term for converting digital video from one kind of compression to another) these video files from their current format to a more ubiquitous format, such as MP4 with H.264 compression. I like using Adobe Media Encoder for these video conversions because it comes with my Adobe Creative Cloud membership, works on macOS and Windows, and supports a long list of input and output formats.

FIGURE 9.11 I rely on Adobe Media Encoder to batch convert a wide variety of video and audio formats to modern, accessible digital formats.

When you convert your vintage digital video files, make sure to retain the original quality, including the resolution, frame rate, and bitrate of the source files. Transcoding video to a new format should make the video easier to enjoy now and in the future, but shouldn't degrade the quality.

> **TIP** Adobe Media Encoder can also convert audio formats such as AIFF and WAV to more accessible formats like MP3 and AAC.

Workflow Tips

Automating the conversion of lots of files can be a huge time saver, but it can feel a little scary if it's your first time. Try these workflow tips to make your digital format conversions go smoothly:

1. Convert a single file multiple times with different settings and unique filenames to compare the results. For example, if you convert an HEIC file to JPEG with different quality settings, what do you notice about the image quality and file size? Find a setting that balances visual quality with file size and meets your expectations for how you want to preserve your photos.

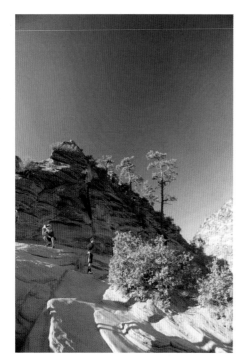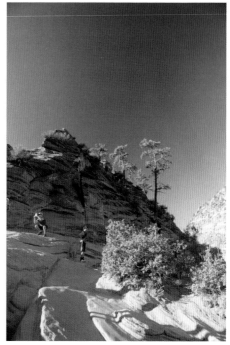

FIGURE 9.12 The image on the left was saved with JPEG quality of 20 and the file size is 545 KB. The image on the right was saved with JPEG quality 75 and the file size is 2.7 MB. The image on the right is five times the size of the image on the left, but the sky doesn't show the ugly banding, and when viewed at actual size (100% zoom), the image details are much clearer.

2. When you find settings you like, save them as a preset that you can use repeatedly. Automated batch conversions will save you hours of time and ensure consistent results. At Chaos to Memories, we use Adobe Lightroom Classic or Adobe Photoshop for all our photo conversions and Adobe Media Encoder to convert all our video and audio files.

3. Before you discard your original files, verify the results of the batch conversion. Did all the files convert and retain the quality you expected?

Remember that file formats and storage media are both important aspects of keeping your digital memories accessible today and in the future. Convert your digital files as needed, keep them on modern storage devices such as hard drives, and keep those drives backed up and safe with an off-site copy. If you're following these workflow steps then you're making great progress and you don't want to lose any of your work!

10

Scanning Physical Photos

One of my favorite services we offer at Chaos to Memories is archival scanning. We scan prints, negatives, slides, albums, scrapbooks, and more. I tell our clients that if you can see it, we can scan it. I haven't found anything that couldn't be scanned, and I enjoy the variety of formats and interesting stories of the photos we scan.

That said, scanning is tedious work that involves gathering, curating, sorting, and cleaning your photos before you even scan them. The actual scanning is just one part of a multi-step process that requires lots of organization, attention to detail, and technical acuity. If you're going to scan all your photos, then I suggest doing it right the first time by getting high-quality scans with good equipment. The only thing worse than a tedious job is doing it twice!

Goals

Before you learn about the equipment and process of scanning physical photos, let's review the goals of scanning.

- **Preservation:** It's important to capture your memories before they fade, discolor, or decay. Scanning also makes formats such as negatives and slides easier to view, enjoy, and back up.

- **Sharing:** One of the challenges of unique physical objects is that there's only one of them, but when you scan a photo it's easy to share your memories. Scanned photos can be shared digitally through phones, email, websites, and social media.

- **Reproduction:** When you capture an archival scan of a photo, you can use the digital file to make new prints and other physical keepsakes, including enlargements, photo books, and wall art. If you apply color correction and digital retouching to your scans, reprints from the scanned files will often look even better than the original photographs.

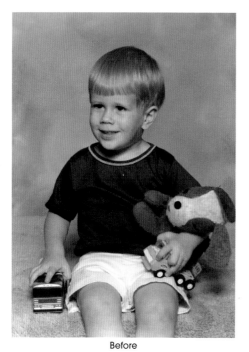
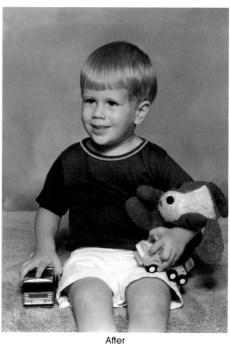

Before After

FIGURE 10.1 Archival scanning and expert restoration can give you digital images that are as good or better than the originals.

I've been scanning for almost thirty years and I've used every kind of scanner to preserve just about every photo format. Scanning requires a tolerance for repetition, attention to detail, and a blend of art and science. Whether you do your own scanning or decide to outsource to an expert you trust, three major factors that affect the quality of a scan are resolution, file format, and image compression. Let's explore these three factors in detail.

Resolution

Image resolution is the level of detail in a digital image, and capturing the appropriate resolution for different photo formats is essential to getting a good scan. Unfortunately, this fundamental aspect of scanning is a common source of confusion. To make matters worse, even scanner manufacturers add to the confusion with their imprecise use of technical terms such as DPI and PPI. Fortunately, looking at the words clarifies our understanding.

- **DPI (Dots Per Inch):** Most people use the term *DPI* when they talk about scanning photos. For example, clients might ask, "Should a photo be scanned at 300 DPI or 600 DPI?" However, there are no dots when you scan a photograph. Dots of ink are used in the professional printing process and DPI is a description of the density of dots of ink on paper, not the quality of a scan. If you use a magnifying glass to inspect a cereal box or newspaper, you'll see this pattern of tiny dots. When viewed from afar, your eyes mix those dots together and you see a smooth image, but when viewed up close, you can see the individual dots of colored ink from the printing process. While DPI is a commonly used term, it measures the quality of printing, not scanning.

FIGURE 10.2 Dots per inch is a measurement of printing density.

- **PPI (Pixels Per Inch):** When you scan an image, the correct technical term to use for image resolution is PPI. This measures how many pixels are captured in one inch when you use a digital capture device such as a scanner or camera. For example, if you scan a 4-inch x 6-inch photo at 2400 pixels x 3600 pixels, then you have a 600 PPI scan.

FIGURE 10.3

Pixels per inch is the measurement of image density when digitizing a physical photograph. Divide the number of pixels by the number of inches to calculate PPI.

I don't mean to be overly particular about the technical terms, but I've always found it helpful to use the correct terminology when discussing technical subjects. It helps you sound like an expert, and you can communicate clearly with others about the quality of your scanned photographs.

Now that you understand the difference between DPI and PPI, let's review recommendations for optimal resolution for scanning different photo formats. These recommended resolutions are based on decades of my own testing, photo industry best practices, and US federal guidelines for digitizing cultural heritage materials.

For reflective media such as photo prints, I suggest a resolution of 600 PPI. This allows you to reprint the image at original size and up to two times the original size if you want enlargements. If you never plan to reprint an image larger than its original size, then scanning at 300 PPI is sufficient.

Now, if 600 PPI is better than 300 PPI, then wouldn't 1200 PPI be better than 600 PPI? That sounds logical, but it's not how it works in the real world. The reality is that 600 PPI is the upper limit of detail that can be captured from most photo prints, regardless of the scanner, software, or computer you use. If you decide to scan a photo at 1200 PPI, the process will take longer and your files will be four times larger, but you're unlikely to capture any more useful visual information. If I was going to err on one side or the other, I'd rather scan at a higher resolution than a lower resolution, but 600 PPI will be the highest effective resolution you'll want to use for scanning photo prints and other reflective media.

The other major category of photo formats is transmissive media, such as negatives and slides. For these items I recommend scanning at 4000 PPI, which aligns with the US federal guidelines for digitizing cultural heritage materials. This captures all the usable visual information in these formats and allows for larger reprints and many creative possibilities. Scanning slides and negatives at resolutions higher than 4000 PPI is possible, but is probably a waste of time and hard drive space.

Reflective Media 600 PPI

Transmissive Media 4000 PPI

FIGURE 10.4 The target resolution is 600 PPI for prints and 4000 PPI for slides and negatives.

TIP Many scanner manufacturers advertise a maximum resolution such as 9,600 or 12,800, but upon further inspection you might find that it's only an interpolated resolution instead of an optical resolution. Interpolation in scanning is similar to digital zoom in a digital camera, it's just made up information. When you scan important photos, make sure you never go beyond the optical resolution of your digital capture device.

Recommended File Formats

There are a few common file formats used by photo scanners and software that you should consider as you tackle this phase of your project.

- **JPEG** images at high resolution and high quality are a great choice in most situations. If you plan to scan and save images without many adjustments, then JPEG is a good option at a much smaller file size. However, if you plan to open, edit, and retouch your images many times, then I suggest you use the TIFF format instead.

- The **TIFF** file format with lossless ZIP compression is a great format for scanning high-quality, high-resolution images. This format has been around since 1992 and is still an industry standard. Because the ZIP compression is lossless, you aren't throwing away quality each time you retouch these files.

- If you camera scan images with a digital camera, then you should use the camera raw format and convert your files to the **DNG** format with Lightroom Classic. This format allows you to capture the maximum resolution, bit depth, and quality of your original photo formats.

Image Compression

It's important to get high-quality scans of your photos, but if you have a lot of high-resolution images, then you also need to factor in the need for lots of storage. And it snowballs from there with bigger backup drives, longer backup times, slower sharing, and increased upload time to cloud services.

Poor use of image compression can cause irreversible harm to your digital files, but when used correctly, compression is a wonderful technology. Let's explore the options so you can make the best decisions for your photo archives.

- **TIFF with no compression:** When you scan photos you can save them as uncompressed TIFF files. This will retain full quality and full resolution, but the files will be very large and require large hard drives and backups.

- **TIFF with lossless compression:** Many people mistakenly think TIFF files don't use compression, but TIFF files actually support multiple kinds of compression. There are two options for lossless compression—LZW and ZIP—which save file size through efficiency and don't discard any image quality. ZIP compression almost always results in smaller file sizes than LZW, and in a surprise twist, LZW can actually *increase* file size in some situations. Therefore, I recommend TIFF files with ZIP compression for the highest quality digital files. These images will have smaller file sizes than uncompressed TIFFs, but with no quality loss.

- **TIFF with lossy compression:** The TIFF file format also supports lossy JPEG compression, which makes even smaller TIFFs, but it does this by discarding some visual information. Not all software supports this compression option, so if you want to use lossy JPEG compression, then save your images as JPEGs.

- **JPEG with lossy compression:** JPEG compression reduces file size by discarding a variable amount of visual information. If you use aggressive JPEG compression, you can get extremely small file sizes, but you will see visual compression artifacts. If you use high-quality JPEG compression, you can still reduce file size by quite a bit, but with no obvious impact on the visual quality of your photos.

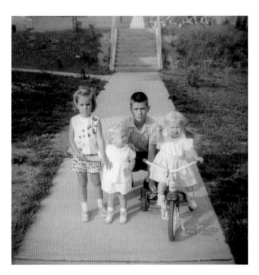

Compression	File Size
Uncompressed TIFF	9.5 MB
TIFF with LZW compression	2.4 MB
TIFF with ZIP compression	1.9 MB
TIFF with JPEG compression	517 KB
JPEG	506 KB

FIGURE 10.5 The visual differences between different compression options are usually imperceptible, but the file sizes can be quite different.

Summary: If you plan to scan photos and do extensive visual edits or digital restoration, then I recommend using the TIFF format with ZIP compression. If you're just scanning your photos and saving the files, then I recommend JPEG with high-quality compression.

Negatives versus Prints

Most people are familiar with scanning photo prints, but did you know that film negatives can be scanned with the right equipment? Any negative format (35mm, 120, 110, APS, etc.) can be scanned, including color and black-and-white film. Furthermore, a negative will almost always render a scanned image with higher resolution, more faithful color, and better overall quality than a scanned print of the same image. Negatives normally show less decay over time than

prints, and negatives are the original camera capture, so if you have a negative and print of the same photo, I recommend scanning the negative. Just make sure to keep the print and negative together so it's easy to organize everything when you're done scanning.

Scanned Print Scanned Negative

FIGURE 10.6 I scanned a print and negative of the same photograph that I took in Tuolomne Meadows back in 1989. Scanning the negative results in more image area, better quality, and higher resolution.

Scanner Options

You have many options to choose from when it comes to scanners, and your decision will include factors such as the photo formats you need to scan, speed, quality, and cost. With these criteria in mind, let's review the hardware options for scanning your photos.

- **Gadget Scanners:** In recent years, there's been a series of "gadget" scanners that promise to scan a variety of formats including prints, negatives, or slides. They typically cost $100–$200 and store digital images directly to an SD memory card. Unfortunately, these offer weak illumination, low resolution, and overall poor image quality. If you're going to scan your photos, don't waste your time with these gadgets.

· **Mobile Apps:** Several mobile apps can scan your prints, negatives, and slides with the camera in your phone or tablet. They claim to capture brilliant, high-quality results, but after extensive testing I can only say the results are terrible. Honestly, I haven't found a mobile app that can even come close to the quality of a twenty-year-old flatbed scanner, so I wouldn't waste your time with these apps for anything more than a preview.

FIGURE 10.7
The scan on the top is obviously a better image and has ten times the resolution of the same photo scanned with a popular mobile app (bottom).

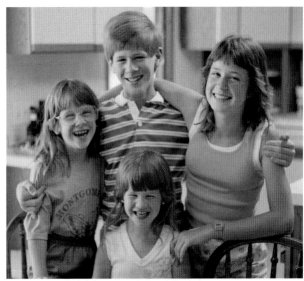
Professional Scan

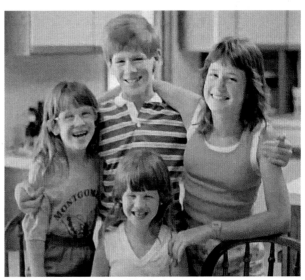
Mobile App

- **Flatbed Scanner:** The most familiar kind of scanner is a flatbed scanner, which looks like a small copy machine. These have a hinged lid, and you place your photos face down on a glass plate. The quality of flatbed scanners is decent, and the price is fair in the $200–$1,000 range. The speed, however, is painfully slow. All flatbed scanners can scan prints, and some have the option to scan some negative and slide formats, which offers more flexibility with a single device. Considering the technology of flatbed scanners hasn't advanced in the last twenty years and taking into account the slow scanning time, I'd recommend this option only for small batches of photos.

- **High-Speed Scanners:** Another type of photo scanner is the high-speed, auto-feed scanner, such as the Epson FastFoto models. These scan standard-sized prints at high speed and decent quality for a price of about $600. Unfortunately, these scanners cannot handle delicate photos, mounted prints, oversized items, negatives, or slides. Manufacturers specifically say that auto-feed scanners can damage delicate photos and that mounted photos can damage the scanner, so this kind of scanner is an option if you have only standard-sized loose prints.

 Another challenge with these auto-feed scanners is that they can be difficult to keep clean. If you have a speck of dust on a flatbed scanner, it shows up as a speck of dust on your scan, but with an auto-feed scanner, it shows up as a pink or white streak across the entire scan. If you decide to use one of these scanners, make sure you have lots of cleaning supplies and use them regularly.

- **Slide/Film Scanners:** These are less popular but are dedicated to digitizing film negatives and slides at very high resolution and quality. These scanners typically cost $500–$1,000 and often include automated dust and scratch removal, which yields impressive results. Classic models from Canon, Nikon, and Minolta were discontinued years ago, but new options are available from companies such as Pacific Image and Plustek. If you consider this option, be aware that they support limited film formats, and high-resolution scanning takes a few minutes per image.

- **Camera Scanning:** In recent years, museums, archives, and photo managers have been adopting camera scanning to digitize any photo format at high resolution, high speed, and high quality. A camera scanning station will cost $2,000 or more, and requires more setup and learning, but using the latest digital cameras yields very high-quality scans. Camera scanning also gives you the flexibility to capture prints, slides, and negatives of any format with one piece of equipment that has a relatively small footprint. In our studio at Chaos to Memories we use camera scanning exclusively and scan dozens of formats, including popular 35mm film, sub-miniature slides, and glass plate negatives from the 1800s.

FIGURE 10.8
Camera scanning is a big investment in equipment, but it allows you to use the latest digital-imaging technology to capture the best possible scan of any photo format.

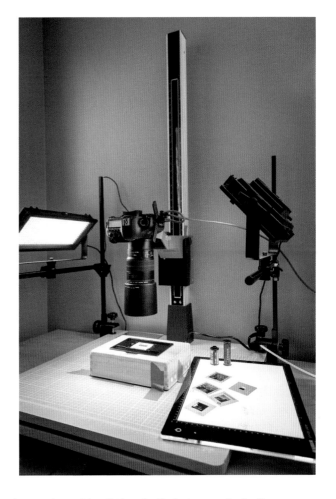

You can setup a camera scanning station with off-the-shelf photo gear including:

- A 24-megapixel (or greater) digital camera—full-frame, crop-frame, DSLR, and mirrorless all work well
- Macro lens with 1:1 magnification and focal length of 50–100 mm
- LED studio lights to illuminate prints
- A light source and film carriers for negatives and slides
- A copy stand to hold everything steady and parallel
- A USB cable to connect your camera to your computer
- Adobe Lightroom Classic to capture, crop, edit, and organize your camera scans
- Negative Lab Pro plug-in for Lightroom to convert negatives

If you want to learn more about camera scanning, you can download my free Camera Scanning Gear Guide from my website at: **chaostomemories.com/camerascanning**.

- **Outsourcing:** I love camera scanning, but I realize it isn't for everybody. In fact, lots of people don't want to scan at all. A few years ago, I had a client who bought an expensive scanner, scanned one very precious photo, and never used it again. She ultimately sold it on eBay for a significant loss when she realized she didn't want to spend her retirement years scanning her photos. She hired me to finish scanning her photos instead, and loved the result without all the tedious work.

If you have lots of time, patience, and attention to detail, then you might love scanning your photos as much as I do. As you consider your options, factor in the cost of equipment, time to learn, and energy required to do the work. If you decide to outsource the scanning of your photos, ask about the recommendations in this chapter, including resolution and file formats. Also ask if cropping, rotation, color correction, and high-resolution files are included or cost extra.

Where to Start

After you decide how you're going to scan your photos, you need to know where to start. There's no right answer to this, but these are a few approaches to consider:

- If you have photos that are damaged or faded, start with those. You can't reverse this damage, but you can "freeze" it with an archival scan.

- If there are special photos in your collection that are cherished above all others, then start with those. Even if the project takes a long time, at least you'll have peace of mind that your most precious memories have been preserved.

- One of my favorite benefits of scanning photos is the ability to share them with others. Therefore, you might start with some of your funniest or whackiest photos that you want to share with friends and family. This can be a great way to connect with others and get them involved in your project.

FIGURE 10.9
It's good to start with any important, damaged photos from a photo collection so that you are able to scan them before the damage gets any worse.

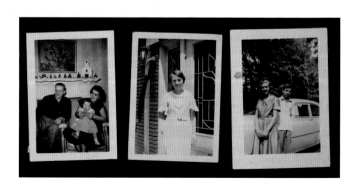

Scanning Tips and Tricks

Scanning photos is such a repetitive task that every little time-saving trick, even if it just saves a few seconds on a scan, will add up to big time savings over the span of a project. These tips are helpful no matter what kind of scanner you use, what resolution you choose, or if you outsource all your scanning.

- Organize your digital photos (see chapter 12) before you scan your physical photos so you don't accidentally scan lots of photos that were printed from digital files you still have.
- Wear gloves to protect your photos from oil and dirt on your hands.
- Keep original envelopes, receipts, and boxes for clues about the dates and details of your photos.

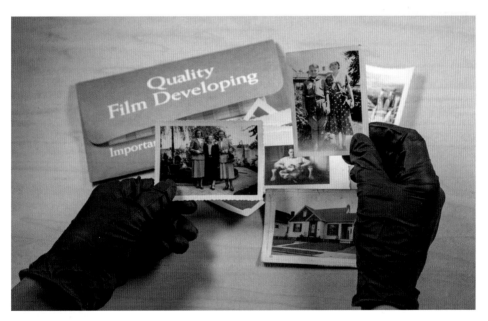

FIGURE 10.10 Always wear gloves when handling photos, and keep any notes or envelopes that might offer clues about the people, places, or dates of the images.

- If you have negatives and prints of the same images, keep them together and scan the negatives.
- Scan like material together for maximum efficiency. For example, scan all your 35mm negatives, then 110 negatives, then prints, so you don't have to switch back and forth.
- Crop and rotate every scan so you see the photo you care about, not crooked, upside-down, or sloppy images.

- Keep track of what's been scanned so you don't accidentally scan it twice. Moving scanned photos from shoeboxes to nice archival boxes is good for your photos and an easy way to keep track of your progress.
- Instead of scanning all your photos into one big folder on your computer, work in small batches. Organizing scanned photos into subfolders that correspond to envelopes or rolls of film makes the project more manageable.

Adding Scanned Photos to Your Photo Archive

In chapter 6 you learned how to use Adobe Lightroom Classic to organize your digital photos into a chronological system that's easy to understand. The beauty of a chronological system is that it's easy to blend your digital and scanned photos into the same archive. If you follow my last scanning tip about working in batches, then naming the folders of scans with a consistent format makes the process even easier.

For example, if you scan a bunch of photos from Christmas 1993, then putting those scans into a folder named "1993-12-25_Christmas" makes your photos easy to find, they'll be chronologically sorted, and they'll use the same consistent date system as your digital photos. I realize sometimes your scanned photos won't have an obvious date or clear subject, but you can still use the same system. If you have some miscellaneous photos from the summer of 1995, you can put them in a folder named 1995-07-00_summer. The "00" is a non-existent date that communicates ambiguity but still sorts logically with all the other date-based folders.

Next, move all your subfolders of scanned photos to one parent folder and name it some-thing obvious like Scanned Photos. Then copy that folder into your Photo Archive folder using Finder (macOS) or File Explorer (Windows).

Now switch back to Lightroom, open the Import dialog again (File > Import Photos and Video), select your Scanned Photos folder in the Source section on the left side of the dialog, and choose the Add option at the top. Click Import in the bottom-right corner, and Lightroom will import all your scanned photos, while retaining the existing folder structure. If you want to change the dates of your scanned photos so they reflect the dates when they were taken instead of the dates they were scanned, then you'll want to check out chapter 13 (page 152).

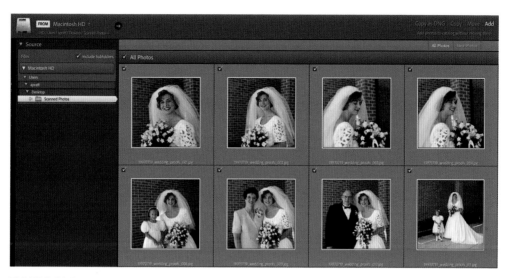

FIGURE 10.11 Import scanned photos into Lightroom Classic with the Add option in the Import dialog to retain your existing folder organization.

Video Conversion Best Practices

This book is all about preserving and organizing photos, but you probably have video memories you also want to enjoy again. The equipment required for this work is so specialized and expensive that you should probably outsource this to a trusted expert. These are the best practices we use for our Chaos to Memories clients:

- Film reels such as Super 8, Regular 8, and 16mm can be captured as high-definition digital video files. We use a sprocketless capture system, which significantly reduces the risk of damage to old film.

- Analog tapes such as VHS, Hi8, and Betamax can also be converted to digital video files. We typically use a resolution of 640 x 480 pixels, which is plenty to capture all the detail of the original format.

- Digital tapes such as MiniDV can be captured as digital video files with no quality loss at original resolution, which is almost always 720 x 480 pixels.

FIGURE 10.12
Home movies come in a
variety of formats, including
film reels, videocassettes,
and DVDs.

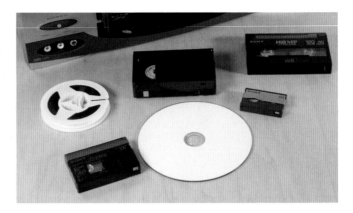

Capturing the full resolution of the original video is important, but sometimes people request the "highest-quality video" without realizing what they're asking for. If you're preserving original video from significant cultural events or national history, then you might capture a sequence of uncompressed TIFF files or uncompressed AVI files. These are technically the "highest-quality video," but the file sizes are enormous, the playback is challenging, and sharing is almost impossible without large hard drives. Instead, we convert all home movies to MP4 digital files with high-quality H.264 compression. These files are small enough to store and share, universal (so they should be accessible in the future), and retain high-enough quality to be edited. You might not be familiar with the technical jargon of MP4 and H.264, but these are the same video standards that drive major video services like YouTube and Netflix, and they'll be supported by any good video-conversion software.

After your movies are converted to digital video files, giving them a name that includes the original capture date (when known) and the subject is more intuitive than naming them tape12.mp4. For example, if we convert a tape from Christmas 1993, we name that file 1993-12-25_Christmas.mp4. You might not always remember when a video was shot, but if you look for timestamps on the video, labels on the cassettes, or postmarks on film reels, you can find a lot of useful clues.

Finally, make sure to mark every tape or reel after it's been converted so you know what's complete. That way you or others won't accidentally convert the same tape twice.

Sample Scans

Scanning is an important part of the workflow, but it's also very repetitive. That's why it's important to choose the right equipment, scan at the best resolution, and choose the optimum file format for your scans. I strongly recommend starting with some sample scans and checking important details such as resolution, quality, and file size. You don't want to scan 10,000 photos only to realize you used the wrong resolution or had a speck of dust on your scanner.

PHASE 3:
Organize

Gathering and preserving your photos are important steps, but if you can't find your photos the project is incomplete. I start this phase by organizing all images chronologically, checking again for duplicates, and deleting any duds. In addition to using dates, I also tag photos with information such as people, places, and events. With an organized Family Photo Archive you can find your favorite photos in seconds instead of browsing through images for hours.

11

Curating Photos

Many of my friends are professional photographers, and I know they delete tons of their photos so they can focus on their best shots. In fact, I've heard Jimmy Chin, one of the top adventure photographers in the world, speak about his editing process, and he typically deletes half his images during his first round of edits.

As a professional photo organizer, it's interesting to me that the world's best photographers delete many of their photos, but many amateurs tend to keep everything they shoot. We could all learn from Jimmy!

In this chapter, I'm giving you permission and a process to delete your bad photos. A lot of what you'll learn is about workflow and technology, but curating photos is also deeply personal. I know that it can be hard to delete photos and discard prints. But instead of holding on to every photo you've shot, I'm going to encourage you to save the best and delete the rest. I want you to declutter your photo life and enjoy your memories again.

What Is Curation?

We usually hear the word *curation* in relation to museums and art galleries, but art curators aren't focused on throwing away the mediocre pieces. A curator selects the best material to put on display. There are thousands of pieces of art and history in warehouses, basements, and private collections, but in a museum we see the best items only.

This is instructive for us as photographers because most people use the word *culling*, which is more about deleting your bad photos. Honestly, most of us are taking so many photos that we can't afford to just cull out the bad ones. Instead, you should keep the best and delete the rest. Turning the curation process upside down is a big shift in thinking, but it will be a more delightful experience for you, and you will create a better photo archive for posterity.

If you start with clear criteria, then the process is simpler, even pleasant. For personal photo collections, these are the kinds of photos you want to keep:

- **Telling stories:** People are using their phones to take a lot of photos of random things, such as their lunch or shoes they might buy, but you want photos and sequences that tell stories.

FIGURE 11.1 Delete the random reminder shots, and focus on the photos that tell stories.

- **Connecting with people:** Focus on photos that reveal relationships, show personal interaction, and capture human reactions.

- **Capturing emotion:** A photo of a child posing with a gift is fine, but I'd rather have the photo of them showing genuine surprise.

FIGURE 11.2 There's nothing wrong with a posed photo, but everybody enjoys a photo that highlights human interaction.

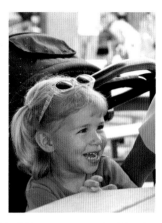

FIGURE 11.3 A great photograph captures emotion, not just the scene and subject.

· **Preserving memories:** Not every photo has to be technically excellent. It's okay to keep a photo even if it's not a great photo, but is still a great memory. A mediocre photo is better than no photo.

FIGURE 11.4
There are many things I wish I could change about this photo, but it's the only image I have of this person.

- **Not just smiles:** Sad photos are allowed. Sometimes life is hard, and it's okay to take photos of those days and keep them. One of my favorite photos is when our son Josh wasn't feeling well and my wife was comforting him tenderly. It's not a happy photo, and nobody is smiling or saying cheese, but it's a beautiful photo that captures a mother's love for her son.

FIGURE 11.5
You don't always have to say cheese!

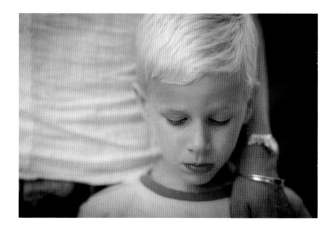

- **Good composition:** Make sure there's a clear subject that is well positioned within the frame, and that nothing's sticking out of the heads of your subjects. Taking a moment to compose your shots can result in dramatically better photos.

FIGURE 11.6
An alarming number of photos I organize for clients don't have a clear subject, so I encourage folks to slow down, compose their shots, and make better photographs.

- **Good exposure:** Common mistakes to avoid are photographs that are too dark, too bright from harsh flash, or backlit against a window. In Adobe Lightroom Classic you can use the Histogram panel to evaluate if a photo is underexposed, overexposed, or just right.

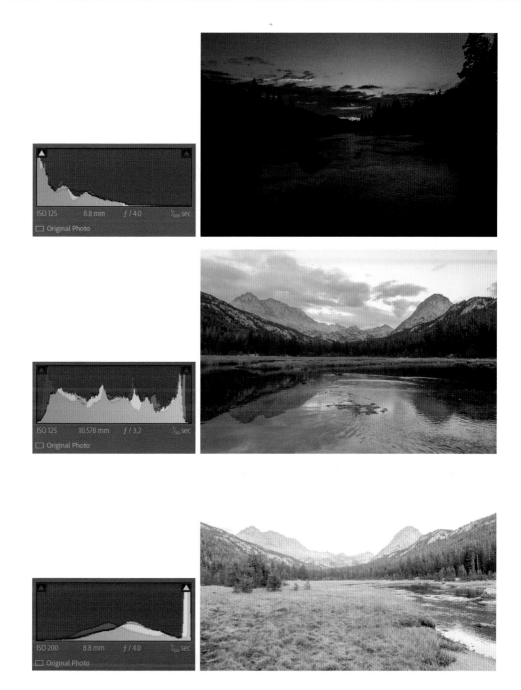

FIGURE 11.7 Most photos with good exposure will have a histogram that looks like a mountain range spread from left to right, with no spikes on the left (shadows) or right (highlights).

- **Multiple angles:** It can be helpful to capture the same scene from multiple angles. Sometimes the best shot is from an unexpected perspective.

FIGURE 11.8 After I finished running the Oklahoma City Marathon, I spent some time taking photos of the memorial of the 1995 bombing. I adjusted my camera and moved my feet to find new angles on this special place.

- **Multiple orientations:** If you plan to use your photos for creative projects, capturing a portrait and a landscape version of the same shot gives you more creative freedom. For example, the portrait version of the shot below might look great on a canvas gallery wrap, but the landscape would work better in a slideshow because you won't have those unsightly black bars on the edges.

FIGURE 11.9 Shoot and edit with multiple orientations, and you'll give yourself more creative options.

- **Different crops:** I tend to shoot pretty tight, but I've learned to step back or zoom out. Capturing both the intimate details and the wider scene helps you tell a better story.

FIGURE 11.10 This portrait sequence shows how different crops can reveal the scene and details of a moment.

The best photos make you feel something, and these are the criteria I have in mind as I curate photos. Depending on your interest and skill in photography, you might have other goals that are important to you. If you're a portrait photographer shooting families, a commercial photographer shooting assignments, or a wedding photographer shooting the big day, then your curation criteria might be different. Decide if you like my criteria or you're going to set your own, and then write them down so they guide your curation process.

When to Curate

As usual, I believe that *when* you curate your photos matters, and it's different depending on whether you're working with physical or digital photos. My curation strategy is the same, but the timing is different:

- **Physical photos** should be curated before you scan them, because you don't want to waste time and money scanning photos you don't care about.

- **Digital photos** should be curated after you've deduplicated your collection (see chapter 5), but before you organize photos with metadata and consistent filenames (see chapter 12). You don't want to waste time adding keywords to digital photos that you're just going to delete, right?

Delete the Duds

I'm obsessed with efficient workflows, so my goal is to accomplish the most amount of work in the least amount of time. A great way to achieve efficiency in the curating phase of photo organization is to delete entire categories of images when possible. For example, can you delete:

- All the PNG files from your collection? PNG files are usually screenshots and internet memes that can be deleted. Use the Library filter in Lightroom to isolate these in an instant.

FIGURE 11.11
Use the Library Filter
(**Command/Ctrl+L**) to
isolate photos you might
want to delete based on
file type, camera model,
or date.

- All the files taken with a specific camera or lens? Again, the Library filter is your friend.
- Photos of food, shopping lists, shipping labels, and other reminders? Are there other categories of photos that you shot for convenience but don't need to keep?
- Bad photos? After these broad categories, there still might be lots of photos to delete that are out of focus or suffer from bad exposure, flash failures, poor composition, blinking eyes, unclear subjects, or objects blocking the lens. These distract from your good photos, so delete them ruthlessly.

I use Adobe Lightroom Classic to preview lots of images and delete the duds quickly with these shortcuts:

1. Select images you plan to delete and press the **X** key to flag them as Rejected. Notice that rejected images aren't deleted immediately, but display a small black flag and are grayed out in the Grid view of the Lightroom Library module.

FIGURE 11.12
Select photos you want to
delete and press the **X** key
to mark them as rejects.

2. If you change your mind and want to keep one of the photos you marked as a reject, select the image and press the **U** key to unflag it.

3. Enable Auto advance by pressing the **Caps Lock** key, and Lightroom will automatically advance to the next image after you've marked it. This might not seem like a big deal, but when you're reviewing large photo collections, it reduces your keystrokes by fifty percent.

4. When you're ready to delete the rejected images, choose the Photo > Delete Rejected Photos command and click "Delete from Disk." This will remove your rejected photos from your Lightroom catalog and put them in the Trash (macOS) or Recycle Bin (Windows) on your computer.

FIGURE 11.13
Press the **U** key to change your mind about any rejected photos.

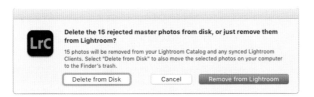

FIGURE 11.14 When you've made your final decisions, delete the rejected photos from disk.

If this process makes you nervous, don't forget that you have a backup of all your gathered files. But there's no need to worry. Based on the projects we see at Chaos to Memories, most people don't cull aggressively enough. Right now you're just sorting through the "junk" pile, so it's a great time to practice ruthless culling!

Save the Best

Now that the duds are gone, it's easier to focus on saving your best and most memorable photos. To select your best photos, use the criteria I listed earlier in this chapter and follow these steps:

1. Select your best photos and press the **P** key to flag them as a Pick. Notice that picked images display a small white flag icon. This doesn't move or change your files, but it marks them with your intentions to keep them as your best photos, and you can still do a second review and change your mind.

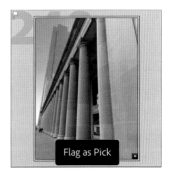

FIGURE 11.15
Press the **P** key to mark your favorite photos as Picks.

2. When you're selecting your best images, consider working from the last photos to the first in each batch, which is opposite from how most people do it. When you're taking photos, you typically start with a test shot, then shoot a couple more, and finally stop shooting when you've captured your best shot. So if you're looking for your best photos, it makes more sense to work from the last photo to the first.

3. If you change your mind and don't want to keep a Pick image, select it in the Library module and press the **U** key to unflag it.

4. Now run the Library > Refine Photos command, and all of your unmarked images will be marked as Rejected and all your Pick images will become unmarked.

Delete the Rest

If you've followed my workflow to this point, then your dud photos have been deleted, all your best photos are unmarked, and all your unremarkable photos have been flagged as Rejects. If you're feeling good about your decisions, then choose the Photo > Delete Rejected Photos command and click "Delete from Disk."

If you're feeling trepidation about deleting too much, follow these steps to double-check your work:

1. In the Library module of Lightroom Classic, make sure View > Show Filter Bar is enabled.

2. Click on Attribute in the Library Filter, and then click the black flag attribute to reveal only the photos that are marked as Rejected from the previous step in the workflow.

FIGURE 11.16 Use the Library Filter to review all rejected photos before making a final decision.

3. Review your rejects as needed, and if you decide you want to keep any of the rejected images, select them and press the **U** key to unflag them.

4. After reviewing your photos, click None in the Library Filter at the top of the Grid view.

5. To delete all your unremarkable and rejected photos, run the Photo > Delete Rejected Photos command and click "Delete from Disk."

6. At this point, you should have just your best photos left, leaving you with a huge sense of relief that you've kept the photos you care about, and all the duplicates and duds are gone. The next step is to empty the Trash (macOS) or the Recycle Bin (Windows) to permanently purge your deleted files.

The last step in this phase is to celebrate the joy of decluttering your photos. Well done!

Star Ratings

I'm not a fan of star rating systems, but because lots of photographers use them, I think they're worth a brief discussion. I know folks who use five-star ratings where five stars represent their best images, four stars are their pretty good images, three stars are their mediocre images, two stars aren't great, and one star is bad.

I don't like this approach because I think you're better served by deleting all of your bad and mediocre shots instead of keeping them and spending time rating them. I mean, who would buy a cookbook from a famous chef with all of their two-star recipes? If the goal is a curated collection, let's make some hard decisions. Life's too short for one-star images!

For better or worse, there's no industry standard interpretation for star ratings. If you're a professional photographer who's committed to star ratings, let me suggest a simple system. After you've curated and organized your photo archive, you might apply these star ratings to help you manage your photos:

- Five stars: Photos that have won awards and public recognition
- Four stars: Photos that have been published in publications or campaigns
- Three stars: Photos you include in your client-facing portfolio
- Two stars: Best of the shoot

If you haven't already guessed, I suggest not bothering with one-star ratings. If it's really a one-star image, why haven't you deleted it already? To apply a star rating to a photo, select the photo and press a number from 1 to 5 on your keyboard. To remove a star rating, select the image and press the 0 (zero) key.

While this star-rating strategy makes sense for pro photographers, what if you're an amateur, mom, or grandpa? In that case, I suggest assigning a five-star rating to a few dozen of your best photos every year. This makes it easy to complete creative projects such as holiday cards, photo books, slideshows, and calendars.

Whatever you do, be simple and consistent. A simple system spanning decades will ultimately be more useful than a complicated system that nobody else understands.

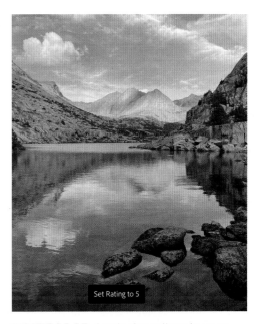

Set Rating to 5

FIGURE 11.17 Apply star ratings to your favorite photos with the number keys on your keyboard.

Curation Process

The curation process is literally thousands of comparisons and decisions. Doing this for a living, I've become very efficient at it, but it's still exhausting and complicated. It can raise questions about the quality of your photography, your identity as an artist, and even the complexity of relationships. Here's what I've learned about the curation process that will help you do this better and faster:

- **Set a goal:** If you have ten photos of the same scene, do you want to keep one, five, or nine? How aggressively do you want to curate your photos? Decide how you want to approach this phase and set boundaries and expectations for your curation process.

- **Work in small batches:** Our average Chaos to Memories client has more than 100,000 digital photos in their collection. If you're anywhere close to this (or over), then curation feels like a daunting task. The reality is that you can't evaluate 100,000 images at a time, so breaking it into smaller batches is essential to tracking your progress, experiencing success, and not feeling overwhelmed. I organize photos chronologically, so I usually curate photos one day at a time, one year at a time. With practice, you'll find a pace and process that works for you.

 If you're catching up on years or decades of photos, it's especially important to tackle them in bite-sized chunks. For example, most people started using digital cameras in the early 2000s, so that can be a great place to start. You probably took fewer photos in the early 2000s than you do today, you're more removed from them, and you can feel a sense of progress as you work through your photos year by year. By the time you're working on recent years, when you might take thousands or tens of thousands of photos a year, your curation habits and decision-making skills will be fine-tuned.

- **Multiple passes:** It can be hard to make all these decisions, so remember that your initial edits are not carved into stone. You can make multiple passes on one batch and change your mind. Making many passes is probably evidence of too much indecision, but with practice you'll get better.

- **Take breaks:** If you're experiencing decision fatigue, take a break and come back later. Often, decisions that are hard on Monday become easier on Tuesday. Just give it a day or a week, whatever it takes, and return to the project with fresh eyes.

- **Leave options:** It can help to have multiple images of the same scene, such as portrait and landscape orientation, wide and tight zoom, serious and silly. If you use your photos for creative projects such as photo books, these options are especially helpful. I'm all about curation, but I don't want you to be so aggressive that you regret it later because you've limited your ability to complete creative projects and tell stories.

- **Pretend you're selecting a magazine cover:** Imagine you're a world-famous photographer submitting images for a magazine cover. You're curating your best work and submitting two to three images, not everything you shot of a given subject.

FIGURE 11.18
I encourage you to keep just your best photos, but don't curate so aggressively that you limit your options for creative projects.

Wide Tight

Serious Smile

Portrait Landscape

- **Toss the trash:** When you're done curating, make sure you actually delete the files and move on. Keeping your rejected files is the digital equivalent of hoarding. If you're afraid to delete your digital trash, take a note from home organizers who set stuff aside for a week to see if it's missed. Try this with your digital photos, then revisit your photo archive after a week. I expect you'll feel more joy and freedom about preserving your best photos, and you'll be convinced it's time to empty the trash!

Lightroom Workflow Accelerators

I've been using Lightroom since the very first version, and I've used it to organize several million photos over the years. With this history and very focused use, I've developed several workflow tips to make the curation process as fast as possible. The first few tips include basic view options:

- In the upper-right corner of the Lightroom interface, you'll notice several modules (Library, Develop, Map, etc.) that let you do different things with your photos. When you're curating your photos, make sure you're in the Library module because it has the best features and fastest speed for this phase of the workflow.

- You'll want to look at your photos in different ways as you review them, and there's a keyboard shortcut for each view mode:

 - **G** is for the Grid view, where you can see thumbnails of all your images.

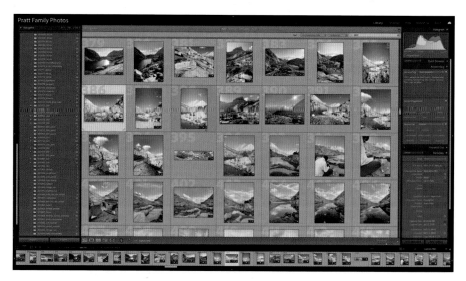

FIGURE 11.19 Grid view

- **E** is for Loupe view, which shows you just one photo at a time.

FIGURE 11.20 Loupe view

- **Z** is for Zoom view, which zooms in to 100% so you can see the details of your photo. Zooming in to 100% is important because almost any photo looks good zoomed out. That's why we think our photos look great on our smartphones. When you zoom in to 100%, you can see details such as blinking eyes and out-of-focus areas that will make you a better photo curator.

FIGURE 11.21 Zoom view

One of the reasons I love Lightroom is because it lets me minimize the user interface and prioritize my photos with these features:

- Press **Shift+F** multiple times to cycle through the three Screen modes: Normal, Full Screen with menu bar, and Full Screen. I prefer Full Screen because it leaves maximum room for my photos, and I can always access the menu bar by moving my cursor to the top of my screen.

- Press the **F** key to enter Full Screen Preview, which is a quick way to hide all the interface elements and just present the active image in full-screen view. Press the **F** key again to exit Full Screen Preview.

FIGURE 11.22 Full Screen Preview

- Press the **L** key multiple times to cycle through the three Lights Out modes: Lights On, Lights Dim, and Lights Off. These hide the interface with an opaque black or translucent gray overlay so you can focus on your images.

FIGURE 11.23 Lights Dim mode

- Press the **Tab** key to temporarily hide the panels on the left and right side of the screen. Press the **Tab** key again to bring the panels back. To toggle all the panels (left, right, top, and bottom), press **Shift+Tab**, and press **Shift+Tab** again to bring them back.

FIGURE 11.24 Hidden panels

Did you know the human brain isn't good at comparing images over time, but is much better when comparing photos side by side? That's why Lightroom offers so many ways to compare images. Try these options to help you decide what to keep and what to delete:

- **Survey Mode:** Select multiple images in the Grid view or in the Filmstrip at the bottom of the screen, and press the **N** key (for N-up) to compare multiples images at once.

> **TIP** To select discontiguous images, hold down the Command (macOS) or Ctrl key (Windows) as you click on each image.

FIGURE 11.25 Survey mode

- **Compare Mode:** I typically use the Survey mode to narrow down my choices, and when I need to decide between two similar images, I switch to Compare mode by pressing the **C** key on the keyboard.

FIGURE 11.26 Compare mode

- **Zoom:** When you're in Compare Mode, click on one image to zoom in, and both photos will zoom to the same location at the same level of magnification. This is especially helpful when you're trying to determine which photo has better focus or which photo has a subject with their eyes closed. Remember, noses and ears can be out of focus, but focused eyes are essential to a good portrait.

FIGURE 11.27 Zoom mode

- **Navigator panel:** The Navigator panel in the top-left corner of the Lightroom interface is a convenient way to zoom in and pan around large images. When you're done inspecting your image, click the Fit option in the Navigator panel or just press the **Z** key to zoom out.

FIGURE 11.28
Navigator panel

Curating Physical Photos

When you curate digital photos, you just delete them and—poof!—they disappear from your hard drive. With physical photos, there are other considerations because you're dealing with physical objects. You have four options when curating physical photos:

- **Discard:** If they're duds or photos you don't care about, you can discard or destroy them. Unfortunately, most photo prints, slides, and negatives cannot be recycled. You can just toss them out with the trash, or if you're concerned about privacy, you can shred them. But don't mingle shredded photos with recyclable paper.

- **Distribute:** If you have double prints or photos that aren't meaningful to you, consider distributing them to family or friends who might appreciate a blast from the past.

- **Keep and scan:** For the photos you want to keep, I suggest you get them scanned so they're easier to enjoy, share, backup, and use in creative projects. Keep matching prints and negatives together, and keep any envelopes, binders, or boxes for the clues they might contain. There is a lot more information about scanning in chapter 10.

- **Keep and don't scan:** Sometimes you'll have physical photos you want to keep, but you don't want to spend the time or money to scan them. In this situation, I suggest you keep them with the rest of the photos from that roll or batch, but turn them backward in the stack. This keeps everything together and organized, but it makes it clear which ones you want to scan and which ones to skip.

TIP Scan your photos and check them for clues before you discard any double prints.

Figure 11.29 shows four identical prints of my wife's grandfather serving in World War II, each with different flaws and notes. From these four prints, I was able to gather names, dates, and other details, along with the best possible scan before deciding what to do with the originals.

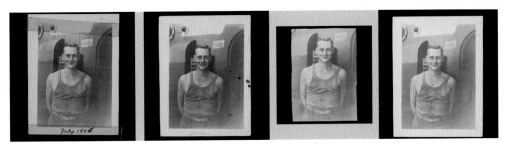

FIGURE 11.29 Get the best possible scan and all available clues from double prints before you decide what to do with the originals.

Curate with Purpose

The deduplication process deletes lots of photos quickly, but the curation process takes more time and demands your brain and your heart. Making these decisions means you must look at your photos with a critical eye, but a thoughtfully curated photo archive is a joy for you and a blessing to others.

Ansel Adams, one of the greatest photographers of all time, wrote, "Twelve significant photographs in any one year is a good crop." I'm not suggesting you should keep only your best twelve photos from each year, but I think we can all learn from Ansel to slow down our photography, compose more carefully, and curate more purposefully.

12

Organizing Photos

If I was flipping through this book in a bookstore, this is the chapter I would pay most attention to. (Hello there!)

I'd want to know what a photo organizing expert has to say about organizing photos. Back in chapter 6, you learned how to organize your digital photos chronologically. And in chapter 10, you learned how to add scanned photos to your archive. Now it's time to combine that date-based file structure with industry-standard metadata that makes your photos instantly searchable and easily shareable.

What Is Metadata?

Many people have old printed photos with handwritten notes on the back that record the date, people, location, event, and photographer behind the image. Metadata is the digital equivalent of those notes, but instead of handwriting on the back or edge of a print, the information is searchable text related to the digital file.

FIGURE 12.1 People used to make handwritten notes on the backs of family photos, and today we do it digitally with searchable metadata.

You might not realize it, but in our digital world we interact with metadata every day. If you search the web for a plane ticket, the results include details such as the departure time, aircraft model, and on-time arrival percentage, which are all types of metadata related to airline flights. If you search for a book on Amazon, the name of the author, publication date, and page count are all types of metadata about books. And if you use Facebook or Instagram, hashtags like #zionnationalpark and #80shair are examples of metadata that make content easier to find.

These examples from other industries show how metadata makes it easier to find what you care about without sifting through an overwhelming about of data. Considering how many photos we're taking these days, metadata can help us find and share the photo memories that are important to us.

When you look at a digital or scanned photograph, the file can contain four kinds of data:

- **Pixels:** Pixels are the tiny colored squares, arranged in a grid, that create a photograph. The visual image you see with your eyes when you look at a digital or scanned photo is composed of pixels, but that's not the only data in a digital photo.

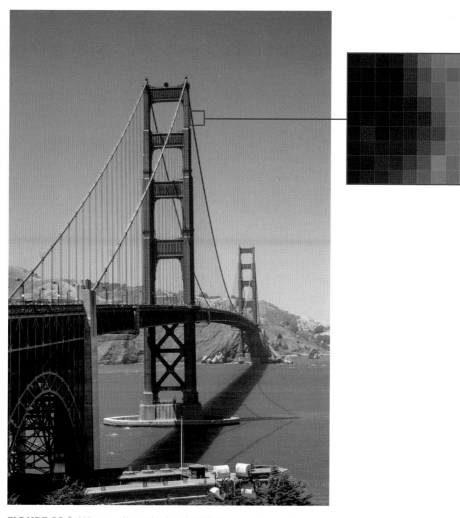

FIGURE 12.2 We see the pixels of a digital photo, but that's not the only information in a digital file.

- **EXIF Metadata:** When you take a digital photo with a digital camera or phone, some metadata about the camera is automatically captured and saved inside the digital file. Details about the exposure, such as the model of camera, focal length of the lens, and shutter speed, are all saved as part of the EXIF (Exchangeable Image File Format) metadata. This is an industry standard that was introduced in 1995 and is consistent across any kind of digital camera regardless of brand, model, or price.

EXIF metadata isn't something you see in an image, but with the right computer soft-
ware, photographers can inspect this information and learn why some photos turned
out better than others. For example, maybe a photo is blurry because the shutter
speed was too slow or a photo is grainy because the ISO setting was too high.

EXIF metadata is always automatic and accurate, so there's no need to edit most EXIF
metadata fields. For example, if you shot a photo with a 50mm lens, there's no reason
to change the EXIF metadata to pretend you shot it with a 35mm lens. Or if you shot
a photo with a Nikon camera, there's no sense in pretending you shot it with a Canon
camera. In fact, most EXIF metadata isn't editable because there's no point to changing
it. The most obvious exception to this is the capture date and time, which we'll discuss
in detail in the next chapter.

FIGURE 12.3

EXIF metadata is captured
automatically and records
technical information
about how the photograph
was taken.

Exposure	¹⁄₁₆₀ sec at ƒ / 9.0
Focal Length	24 mm
Exposure Bias	0 EV
ISO Speed Rating	ISO 400
Flash	Did not fire
Exposure Program	Normal
Metering Mode	Pattern
Make	Canon
Model	Canon EOS 5D Mark II
Serial Number	1721105934
Lens	EF24-105mm f/4L IS USM

- **IPTC Metadata:** If you want to add descriptive information about the content of a
photo, then you'll use IPTC (International Press Telecommunications Council) metada-
ta, which was introduced in the late 1970s for the news publishing industry. Examples
of IPTC metadata include fields for keywords, location, and captions that capture the
story of the photo. This metadata is usually entered manually by a person who under-
stands what's important about a collection of photos.

 In 2001, the IPTC standards organization and Adobe worked together on the XMP
(Extensible Metadata Platform) standard, which is an even more flexible and modern
way to store this important metadata. All IPTC metadata is now saved with the XMP
standard, which became an ISO standard in 2012 and is supported by countless tech
companies around the world. This IPTC/XMP metadata is what you can use to make
your photo archives searchable and is what you'll learn about in the rest of this chapter.

FIGURE 12.4

IPTC metadata is entered manually and describes the content of the photograph.

- **Rights:** The fourth kind of information in a digital photo is metadata about the rights and permissions of an image. For most people, this kind of metadata is irrelevant, but for professional photographers, this is an important aspect of organizing and protecting photos. Rights metadata is a subset of the IPTC metadata, and while it doesn't enforce the law or make it impossible for people to use your photos without your permission, it does help honest people do the right thing. Examples of this metadata include copyright statements, model releases, and contact information for the photographer who created the image.

FIGURE 12.5

Rights metadata is useful to professional photographs, but most people don't need to concern themselves with these fields.

Where Is Metadata Stored?

Now that you understand what metadata is, you need to understand where metadata is saved. There are four options, depending on the software you use, so let's review them all.

 Cloud Service: Apple's iCloud Photos, Google Photos, and Amazon Photos are three of the most popular cloud-based photo services in the market today. All three services include image and facial recognition, which is a big time-saver, but there's also a big catch. These services automatically identify image content (beach, mountain, car, etc.) and store that metadata in their cloud service. This is important to understand because if you take your photos out of these services or want to move your photo archive to a different service, the automatically generated metadata doesn't usually stick with your images.

This feels like a hostage situation to me because these free-to-cheap services use your metadata as a lock-in strategy to keep you using their software, buying their services, and seeing their ads. I resent this approach because I think your photos belong to you, and your family memories shouldn't be trapped by a big tech company. For this reason alone, I don't use or recommend any photo service that stores your metadata in the cloud only.

 Catalog/Library: Some apps store your metadata in a proprietary catalog or library format that manages your images for you. A popular example of this is the Apple's Photos app, which can be used to organize and tag photos even when the cloud features are disabled. Unfortunately, some of these apps store your metadata in the catalog file and suffer the same flaw as many of the cloud-based platforms. If you move photos out of many of these catalog systems, the valuable metadata isn't transferred with the images. Because metadata is so important to making photos searchable and capturing their stories, saving metadata only in a catalog isn't something I recommend.

Sidecar Files: The third place to store metadata is in a sidecar file. These are most common with camera raw files shot by serious photographers. Raw formats, such as Canon CR2, Nikon NEF, and Sony ARW files, cannot include custom metadata, so most software apps that support camera raw files save the metadata in adjacent XMP sidecar files. This is a better option than keeping the metadata in the cloud or a catalog because you have easy access to your metadata, but it's not ideal because if the sidecar file is separated from the corresponding image file, your metadata is lost.

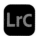 **Embedded:** The fourth and final option (my favorite) is to embed metadata in your digital files so that the metadata sticks with the file anywhere it goes. And if you use industry standard IPTC metadata fields, you can access and search them with any app, cloud service, or website that supports this industry standard. In fact, the IPTC standards organization recommends embedding metadata into digital files as a best practice, and it's what we do on every file for every client project at Chaos to Memories.

One of the main reasons we use Adobe Lightroom Classic for all our photo organizing clients is it embeds metadata in digital files and supports one hundred percent of the IPTC standard for photo metadata. You can select images in a Lightroom catalog and choose Metadata > Save Metadata to Files to embed all your metadata in file formats including JPEG, TIFF, DNG, and PNG.

Metadata is so important to organizing photos that I suggest changing your Lightroom catalog settings as explained back in chapter 6 to automatically write changes into XMP. Here's a refresher on how to do that: Open the catalog settings by choosing Lightroom Classic > Catalog Settings (macOS), or Edit > Catalog Settings (Windows), click on the Metadata tab, and enable the third setting to Automatically write changes into XMP. This ensures all the metadata you're going to apply later is automatically saved into your images instead of only in the Lightroom catalog.

> **TIP** At Chaos to Memories, we use Adobe Lightroom Classic, so that's what I'll use for the following examples. These standard metadata fields can also be edited and embedded with cross-platform apps including Adobe Photoshop Elements, Adobe Bridge, and Camera Bits Photo Mechanic.

Common Metadata Fields

I believe it's important to understand the why and how of photo organizing, and now that you understand the why behind metadata, it's time to learn the how. There are more than one hundred possible metadata fields, but I'm just going to focus on a few basic fields that will help you to organize and search your photos.

In the Metadata panel on the right side of the Library module, you'll want to add searchable information in a few essential fields:

- **Keywords:** This is the most elemental metadata, consisting of individual words or short phrases separated by commas. Keywords can include events, such as *birthday* or *vacation*; places, such as *beach* or *school*; objects, such as *bicycle* or *costume*; and adjectives, such as *silly* or *private*. You don't need to assign a keyword for everything in every photo, but focus on what's memorable about your photos so you can find what's important to you.

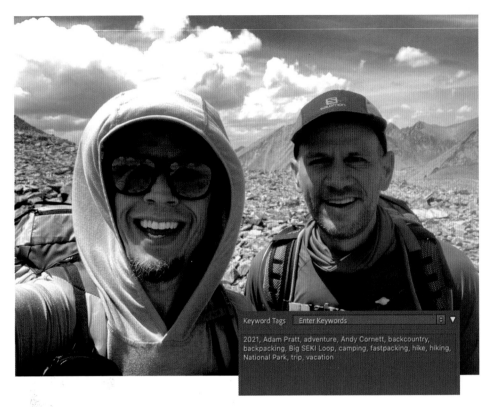

Keyword Tags Enter Keywords

2021, Adam Pratt, adventure, Andy Cornett, backcountry, backpacking, Big SEKI Loop, camping, fastpacking, hike, hiking, National Park, trip, vacation

FIGURE 12.6 Some of the keywords I used on this photo include *hike, vacation,* and *backpacking.*

- **Names:** People are the most important subjects of many photos, and adding names of important people makes your photo archive more rich and searchable. Imagine finding all the photos of your child as you prepare for their graduation, or all the photos of your parent when you prepare for their retirement. You can use the facial recognition feature in Lightroom Classic by pressing the **O** key while in the Library module.

Then, assign names to the face regions that Lightroom identifies. I always use full names, such as William Smith instead of nicknames like Billy or Uncle Bill. The problem with nicknames is that they're vague, and relational names change depending on who is looking at a photo. To me, William Smith might be my uncle, but to other people he might be a son, brother, or cousin.

These are just a few of the reasons I use full names and apply them consistently. When you assign names to faces in Adobe Lightroom Classic, the names are assigned as searchable keywords, and artificial intelligence helps Lightroom get more accurate at identifying new faces. I love when software speeds up these repetitive organizing tasks.

FIGURE 12.7 People are often the most important subjects in a photo, so I use full names and apply them consistently when using the facial recognition features of Lightroom.

- **Locations:** There are several location fields—including Sublocation, City, State/Province, and Country/Region—that you can use to record where a photo was taken. This might not sound important now, but if you've ever seen a hundred-year-old photo from your great-grandmother and wondered where it was taken, then you can appreciate the value of including this information in the metadata of your photos.

Metadata fields like City are self-explanatory, but the Sublocation field deserves some special consideration. One way to use the Sublocation field is for famous locations, such as the Lincoln Memorial or Eiffel Tower. It can also be used to record places of personal significance. You might think about using Grandma's House for a memorial sublocation, but what happens when Grandma moves or passes away? Instead of personal references, I suggest specific locations, such as 153 East College Avenue, which will likely endure for decades, if not generations.

FIGURE 12.8

Location and GPS fields might seem unnecessary, but future generations will thank you.

Sublocation	153 East College Avenue
City	Frostburg
State / Province	Maryland
Country / Region	United States
ISO Country Code	USA
GPS	39°39'1.65" N 78°55'32.892" W

- **GPS:** Did you know that GPS coordinates can be embedded in a digital photo to record exactly where on the planet it was taken? This is common with photos from smartphones, but coordinates can be added to photos from a digital camera or even scanned photos. Just switch to the Map module of Adobe Lightroom, select photos in the Filmstrip at the bottom of the screen, and drag them onto the correct location on the map. Even if a person moves, a street address changes names, or a building is demolished, the GPS coordinates will always stay the same and future generations can revisit important locations in their family history.

- **Caption:** The metadata fields described above are like the ingredients, and the caption is the story. I try to write one to two short sentences that capture the who, what, when, where, and why of a photo so that family members and future generations understand the story behind it. I don't write a unique caption for every photo, but if I have photos from an important event or trip, I write a brief caption and apply it to all the photos from that batch.

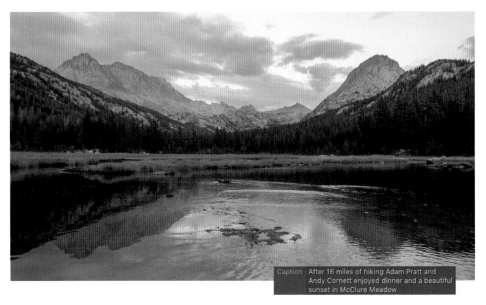

Caption After 16 miles of hiking Adam Pratt and Andy Cornett enjoyed dinner and a beautiful sunset in McClure Meadow

FIGURE 12.9 Consider writing a short caption for your best photos to capture the stories that go with the images.

Workflow Tips

Metadata is a powerful way to organize your photos and make them searchable, but it can take a lot of time to apply. Remember that metadata is for you, and you are its master. You shouldn't feel enslaved to metadata. In other words, don't complete a bunch of metadata fields just because they're available. Instead, use metadata to organize what's important to you and what you think will be interesting to future generations. Here are a few of my favorite workflow tips for getting the most out of photo metadata:

- **Apply keywords only for what you would search.** For example, there might be sand and shovels in a picture from vacation, but if you'll only search for *beach* and *Hawaii*, then use those as your keywords.

- **Apply metadata in batches instead of one image at a time.** If you want to tag your vacation photos with the keyword *vacation*, you can do that for 500 photos at once instead of tagging each photo individually. This is good news for new photo organizers because it makes a tedious process much faster.

- **Work from general to specific.** For example, if you go to France for vacation and spend some of your time in Paris and some of your time in Nice, you can add *France* in the country field for all your vacation photos, then apply *Paris* to the City field for photos from that city and *Nice* to the photos from that city. Wedding photography is another good example of the "general to specific" strategy. If you're a pro photographer capturing weddings, you should start by assigning the keyword *wedding* to every photo from the event. On your second pass, you could assign keywords such as *ceremony* and *reception* to more specific subsets of the photos. This is the most efficient way to assign searchable metadata to large collections of photos without tagging each photo individually

- **Consistency is key.** At Chaos to Memories we use all the workflows I've described in this chapter, but more important than any one field is the need for consistency. For example, if you misspell names, use synonyms, or use interchangeable terms such as *Texas* and *TX*, that will make it harder to find the photos you care about. Decide what keywords and locations are important to you, spell them correctly, and apply them consistently. Use autocompletion features in Lightroom Classic to help enforce consistency across your project.

- **Assign names chronologically.** If you're assigning names to faces over many years or decades, then start with the oldest photos and work your way forward. This will train Lightroom to recognize how people age over time, and when you get to newer photos, Lightroom will be more accurate at guessing who's who. If you jump across the decades, it's hard for Lightroom to know a six-year-old boy and sixty-year-old grandfather are the same person, but if you work through the years consecutively, the facial recognition is incredibly accurate even as people age.

- **Document the project.** Metadata is a powerful technology to make your photos searchable for generations to come, but because it can't be seen by looking at the photos, it might not be obvious what can be searched. Use the Metadata > Export Keywords command to save a text file of all the keywords you've assigned to your photos, and keep that file with your Family Photo Archive. Anybody can open that text file and instantly understand more about the project.

Renaming Files and Folders

If I had to choose between searchable metadata and nice filenames, I'd choose metadata every time. You can include lots of searchable metadata in a digital photo that would make for a ridiculously long filename. The good news is that I don't have to choose, and I rename all my files quickly and easily with this consistent filename template:

YYYY-MM-DD_Subject_001.jpg

For example:

2012-04-08_Easter_001.jpg

I use this filename template because it makes all my filenames chronologically sorted, self-explanatory, and unique. This helps other people understand what's in a photo before they even open it, and you don't have to worry about files with duplicate, confusing file-names. You'll never see another IMG_0579_Copy2.jpg again!

After I've gathered, deduplicated, curated, and organized a folder of images, I follow these steps in Lightroom Classic:

1. Select all the photos in a folder, choose Library > Rename Photos, and choose File Naming:Edit to create a new Filename Template that uses the pattern above.

FIGURE 12.10
Create a new Filename Template, and use it to automate the renaming process for every batch of photos you organize.

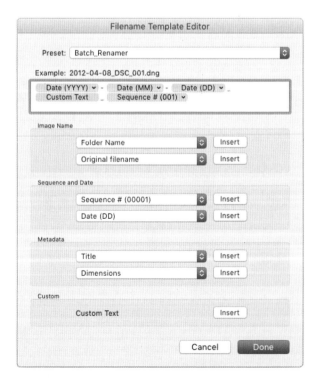

2. Enter the subject of your photos as the Custom Text, and Lightroom will automatically rename all your photos with the same filename pattern.

Rename 49 Photos		
File Naming:	Batch_Renamer	
Custom Text:	Easter	Start Number: 1
Example: 2012-04-08_Easter_001.dng		Cancel OK

FIGURE 12.11 In this example, I just type the word *Easter* and press return, and Lightroom takes care of the rest. This can rename hundreds of photos in seconds.

3. After the files are renamed, rename the enclosing folder with the same custom text. For example, I rename the folder 2012-04-08 to 2012-04-08_Easter. This makes clear to anybody the date and subject of this batch of photos, and it also reminds me of where I left off. A big photo organizing project can feel overwhelming, but by renaming files and their parent folder as the last step in your organizing workflow, it turns the project into its own checklist. If a folder is just named with a date, then it still needs to be organized. If the folder name has a date and subject, then you know that folder is done and requires no more work.

FIGURE 12.12

Renaming your files isn't necessary, but it's an easy step that makes your photos more accessible and intuitive to future generations.

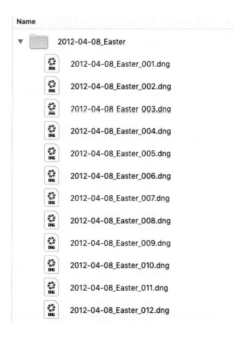

Name

▼ 📁 2012-04-08_Easter

 🗎 2012-04-08_Easter_001.dng
 🗎 2012-04-08_Easter_002.dng
 🗎 2012-04-08_Easter_003.dng
 🗎 2012-04-08_Easter_004.dng
 🗎 2012-04-08_Easter_005.dng
 🗎 2012-04-08_Easter_006.dng
 🗎 2012-04-08_Easter_007.dng
 🗎 2012-04-08_Easter_008.dng
 🗎 2012-04-08_Easter_009.dng
 🗎 2012-04-08_Easter_010.dng
 🗎 2012-04-08_Easter_011.dng
 🗎 2012-04-08_Easter_012.dng

If there's any step in this workflow to skip, it would be renaming files, but using a renaming template makes it so easy that I think it's worth a few seconds. And don't forget to run a backup every time you edit your photos. This is tedious work, and you don't want to lose any of your progress!

These organizing steps are time-consuming, but now you have a clear and consistent plan to tackle any photo organizing challenge. If you've been implementing all the phases of this workflow, then your photos are gathered, deduplicated, curated, sorted chronologically, searchable, clearly named, and backed up. Amazing work!

13

Dating Photos

At Chaos to Memories, we're huge advocates of chronological organizing because it always works and doesn't require a bunch of exceptions and workarounds. However, what happens when dates of digital photos are incorrect or dates of scanned photos are uncertain? The good news is that you can adjust the dates of these files so that the photos sort chronologically, belong together, and make sense to future generations.

Your Family Photo Archive doesn't have to be perfect, but the workflows you're about to learn will make it better organized than ever. In this chapter, you'll learn how to deal with the four most common problems with incorrect or missing dates for digital and scanned photos.

The first thing you need to understand about dates of digital photos is that there are actually seven date fields. This can lead to a lot of confusion, but the secret is that most of these dates don't matter. For example, your computer records when a file was copied to your computer or when it was last modified, but the date you care about is the date the photo was captured with a camera. Therefore, don't worry about dates you see in Finder (macOS) or File Explorer (Windows); focus only on the Date Time Original field, as shown in photo management apps such as Adobe Lightroom Classic.

FIGURE 13.1

The only date field that you need to care about when organizing photos chronologically is Date Time Original.

EXIF dates
Date Time Original 8/1/21 5:38:59 PM

Time Zone Shift

The most common problem with the date and time of digital photos is also the easiest to fix. Imagine you live in San Francisco and travel to Paris for vacation. Paris is nine time zones ahead of San Francisco, so if you're eating lunch at noon in Paris, it's still a dark three o'clock in the morning back in California. If you don't adjust the time zone on your digital camera, when you return and review your vacation photos, you might notice that daytime shots appear as though they were shot in the middle of the night according to their capture time.

FIGURE 13.2
If I don't adjust the clock setting on my camera when I change time zones, I can end up with shots that don't match their actual capture time.

Capture Time 3:02:23 AM
Capture Date Apr 22, 2015

If you take your photos with a smartphone, this time-zone shift shouldn't be an issue because when you land in Paris and disable Airplane mode on your phone, it will set the correct date and time by synchronizing with local cell towers.

The good news is that you can correct mismatched times and dates quickly for batches of photos using Adobe Lightroom Classic. Just follow these steps:

1. Use the Grid view in the Lightroom Library module to select all the photos that need to be adjusted. Remember the phrase "You have to select it to affect it."

2. Choose Metadata > Edit Capture Time, and click the option for "Shift by set number of hours (time zone adjust)."

3. Add or subtract hours as needed to adjust the capture time to match reality.

4. Click the Change button, and in an instant all your selected photos will have corrected capture times.

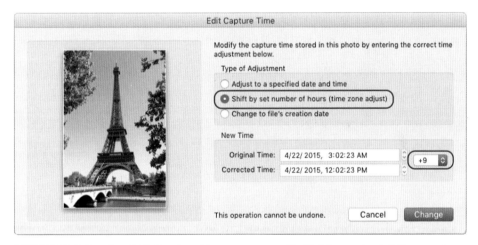

FIGURE 13.3 Use the Edit Capture Time command in Lightroom to shift the capture time of your images forward or backward to correct for time zone changes.

Note that Lightroom doesn't offer an undo feature on date adjustment, but you don't need it. If you make a mistake or need to make further adjustments, just run the same command again to correct the time of your selected photos.

Wrong Date

The second most common reason for incorrect dates and times is when the date of your camera is set on the wrong month, day, or year. This happens often when people get a new camera and don't set it up correctly, but it can also be caused by a dead battery.

When you have the wrong date set in your camera, you'll end up with photos that look like they were taken in the wrong year or season. A good example of this happened on one of my client projects when photos of snow and Christmas trees had capture dates of July 4. When this happens, photos get jumbled, it's hard to remember events, and it's impossible to sort photos chronologically. This can be very confusing and is more important to fix than a simple time-zone shift. Regardless of the cause, this is easy to fix with Lightroom Classic:

1. Use the Grid view in the Lightroom Library module to select all the photos that need to be adjusted.

2. Choose Metadata > Edit Capture Time, and click the option for "Adjust to a specified date and time." **Note:** This option doesn't set the date and time of all selected photos to the exact same values, but shifts all your selected photos relative to the active photo in your selection.

3. Adjust the date and time to the correct values as accurately as you can, and click the Change button.

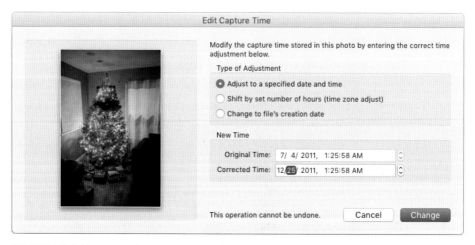

FIGURE 13.4 You can also use the Edit Capture Time command to fix incorrect dates.

Scanned Photos

If I took a photograph on film in 1990 and scanned it in 2020, then the capture date will appear to be 2020. My memory tells me the correct date, and the portraits with big hair offer visual clues about when the photo was taken, but the capture date on the digital file will be thirty years off. If I add those scans with incorrect dates to a chronologically sorted photo archive, things are going to get confusing.

Because my organizing workflow relies on chronological organization, I adjust the dates of scanned photos and integrate them seamlessly with digital photos. The result is a sorted, searchable photo archive that might span decades or generations, regardless of whether the photos are digital or scanned.

Unless you have an amazing memory, determining the original capture date of physical photos usually requires a bit of detective work. You don't have to be perfect, but even getting the right year is helpful, or the right decade for photos from previous generations. Here are some of the clues we use to estimate dates of physical photos:

- Processing envelopes and receipts from the drugstore or photo lab where the photos were printed can be very helpful. These dates indicate the processing date and not necessarily the capture date, but it gets you close. This is a great example of why you shouldn't discard photographic ephemera until everything is scanned, dated, and organized.

- Postal marks on envelopes and postcards can help you know when a photo was taken or returned from a photo processor.

FIGURE 13.5 Dates found on envelopes, receipts, and postal marks can help you date old photos.

- Some photos include the month and year of printing directly on the front edge of the prints. This isn't necessarily the date when the photo was taken, but it can help you estimate the correct date.

FIGURE 13.6
Edge printing can provide helpful clues about when a photo was printed

- Backprinting on photo prints can include the printing date, proprietary lab information, and brand logos of companies such as Kodak, Agfa, and Fuji. These clues can be used to narrow down the era when a photo was taken.

FIGURE 13.7
Most backprinting is useless information, but sometimes it provides the perfect clue to date a photograph.

- Through much of the 1900s, automobile license plates in the United States had the year stamped on them. If you get a good scan, this can be a helpful clue to date your photos.

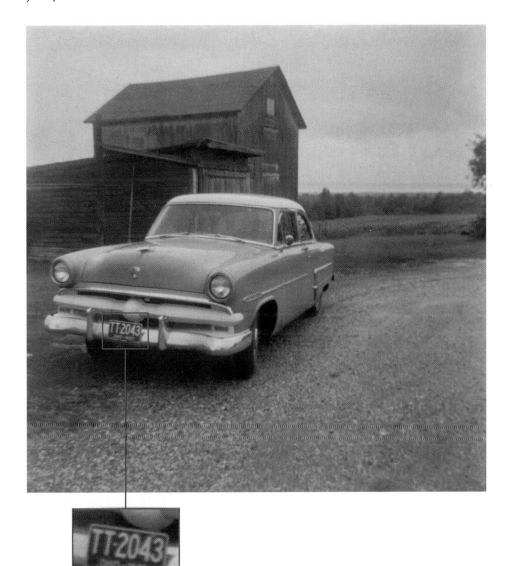

FIGURE 13.8 I'm not a car expert, but this license plate clearly indicates the photo was taken around 1962.

- Birthday parties are one of the most popular times to take family photos. Can you count the number of candles on the cake and determine what year the photo was taken?

- Sometimes distinctive hairdos or clothing styles can help determine when a photo was taken.

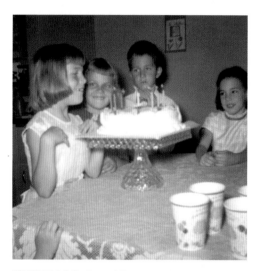

FIGURE 13.9 Count the candles and cross-check with the family timeline to estimate the date of birthday photos.

FIGURE 13.10 Don't ignore clues from fashion and style.

When you have an estimated date for when a photo was taken, follow the same steps discussed on page 152 to adjust the capture dates.

Uncertain or Unknown Dates

I love a chronologically sorted photo archive, but sometimes the capture date of a photo is uncertain or unknown. You can write "around 1976" in the caption field, but it's technically impossible to assign an approximate date to the metadata field of a digital file. For example, if you know a photo was taken in 1976, you can't assign the year and leave the month and day blank.

In these situations, I recommend dating your files as specifically as you can, based on the information you've gathered:

- If you know the *year and month* but not the day, then assign the date as July 1, 1976. The day might not be accurate, but at least it's close and it will sort sensibly by date with other photos.
- If you know the *year* but not the month or day, then assign the date as January 1, 1976. It's not 100% accurate, but you can't leave the month and day values empty and the sort order will still be useful.
- For photos with uncertain dates, you can add *circa* as a keyword, which is a common way to communicate approximate dates.
- You can organize digital photos with uncertain dates into a subfolder with a name like 1976-07-00_vacation. The double-zero is an impossible date, but it sorts chronologically and communicates uncertainty about the exact day.

I suggest fixing dates as you go with the information you have at the time. If your memory gets refreshed or somebody gives you more details, you can always update the dates again with more specificity. This happens all the time with client projects, and you can decide how accurately you want to date photos in your archive.

TIP Metadata in video files is not as technically consistent as it is in digital photos, so Lightroom Classic takes a conservative approach to embedding metadata in video files. By default, Lightroom stores metadata such as dates and keywords in the Lightroom catalog file, but doesn't embed those details in the video files. The good news is that you can use an affordable Lightroom plug-in called jb Video Metadata to embed metadata, including corrected dates, even in video files. We use it all the time on client projects at Chaos to Memories to ensure all our date adjustments are saved permanently. You can download and purchase a license of this helpful plug-in at **lightroomsolutions.com/plug-ins/jb-video-metadata**.

Some of you will get a lot of satisfaction from fixing the dates of your digital and scanned photos so everything sorts chronologically. Others will decide that good enough is good enough and won't bother with all these date and time adjustments. No matter how you approach it, remember that while perfection isn't the goal, general order is helpful and possible.

PHASE 4:
Share

When your Family Photo Archive is complete, it's time to enjoy your photos again. This phase includes uploading the curated photos to a secure online photo sharing service that allows you to search, share, and enjoy your Family Photo Archive on any computer, smartphone, tablet, or web browser. We'll also explore ten creative ways to share your photos with others.

14

Sharing Photos

We've all had that awkward moment when we want to share a special photo but can't find it on our phone or computer. You're searching your hard drive, scrolling on your phone, and searching Facebook, but you can't find what you're looking for. In this situation you feel frustrated, your friend is annoyed, and the opportunity to share and connect is lost.

Wouldn't it be great to search your photos with keywords instead of scrolling? You search Netflix for movies, Amazon for books, and Spotify for music. Why not search your photos like everything else in your life? The value of embedding industry-standard metadata in your photos is that you can search, find, and share your photo memories. And sharing is a major motivation for organizing your photos in the first place.

I've been making a big deal about open standards and metadata, and in this chapter you'll see all that hard work pay off. I had my own lightbulb moment a few years ago when our oldest child was headed off to college. At the last minute, I decided to design a photo book of the first eighteen years of his life. I opened the Lightroom catalog with all our family photos and got to work. Because everything was searchable, I found all the photos with him and selected a few hundred of my favorites in less than an hour. And because all the photos were sorted chronologically and named consistently, I was able to design a hundred-page photo book with those photos in another hour. With a searchable Family Photo Archive, I was able to complete the entire photo book design project in just two hours. Without a Family Photo Archive where everything is searchable and in one place, the same project might have taken weeks and still not had the same storytelling design.

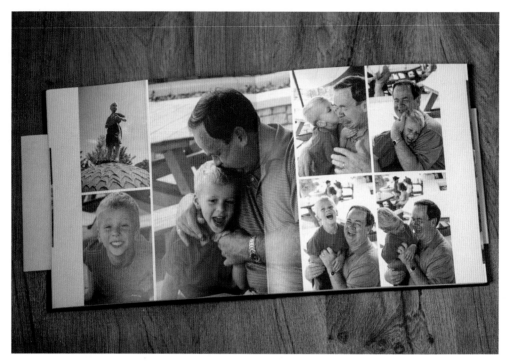

FIGURE 14.1 My organized Family Photo Archive made this photo book project fast and easy.

Searching Your Photos

My example was a photo book, but a searchable Family Photo Archive is useful however you want to share your photos. Whether you want to text a photo to a friend or family member, post it to social media, or use it in a creative project, searching your Family Photo Archive helps you accomplish your goals faster than ever before. The Chaos to Memories team uses Adobe Lightroom Classic for all our projects and that's what you'll see in the examples below, but the principles are relevant for most photo organizing apps.

Let's review some search strategies that make it easier to share your photos:

- Your selection in the Catalog or Folders panel on the left side of the Library module in Lightroom Classic affects what you're searching. For example, if you want to search all the photos in your catalog, choose All Photographs in the Catalog panel. If you want to restrict your search to just one year for a calendar project, then select a year folder in the Folders panel. You can also select just one subfolder or shift-click a range of folders to search a specific range of photos.

FIGURE 14.2
Select folders in the Folders panel to limit the scope of your search. If I were making a photo book about 2021, then I'd select just that folder.

- In the Library module, press **Command+F/Ctrl+F** to open the text search field in the Library Filter. There are many options, but I usually set the search to include Any Searchable Field and Contains All, and then I type my search text in the search field. With these settings, my search will include filenames, keywords, names, and captions. You can start with a general search term, such as *hike*, and you can add other search parameters, such as names and places. In this example, I found all the photos of my son and me hiking in Zion National Park.

FIGURE 14.3 With a quick search, I found this memorable photo of my son and me after we hiked to Angel's Landing.

- Another way to find the photos you want to share is to click the Attribute tab in the Library Filter. If you used star ratings on your favorite photos, you could easily filter all the five-star rated photos from the last year, decade, or lifetime.

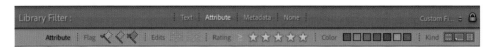

FIGURE 14.4 Use the Library Filter at the top of the Grid view to find all your five-star photos.

- The third option in the Library Filter is the Metadata tab. Work left to right and customize each column to find the photos you want. For example, if I set the left column to City and the second column to Aspect Ratio, I can easily find all the portrait-oriented photos I took in Paris.

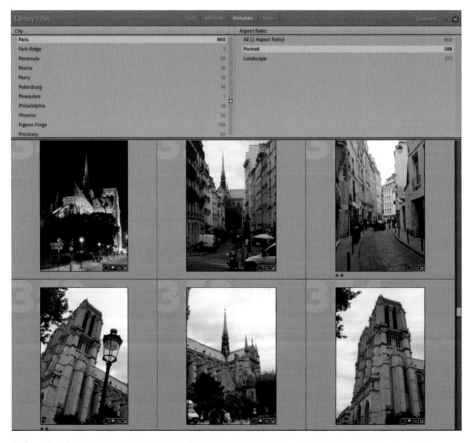

FIGURE 14.5 Use the Metadata filters to search your photos in creative ways.

- My favorite way to search my photos is to combine multiple search criteria to find specific images. For example, if I wanted to print three photos of the Eiffel Tower in a triptych, I could perform a text search for *tower*, and use the Metadata filter to isolate all the photos from Paris with a portrait aspect ratio.

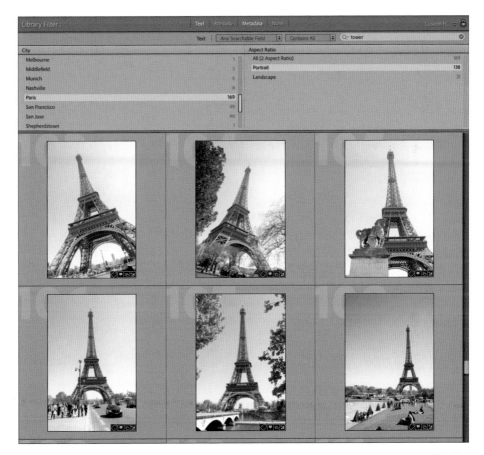

FIGURE 14.6 Combine multiple filters to find the photos you want to share. When you're done, press **Command+L/Ctrl+L** to disable the Library Filter and see all your photos again.

- Another creative way to search photos is based on location. Your digital photos might include GPS coordinates if they were taken with a smartphone, or you might have added GPS coordinates using the Lightroom Map module and the instructions in chapter 12 (page 143). To browse your photos from a global perspective, switch to the Map module and travel virtually around the world.

FIGURE 14.7

The Map module in Lightroom can be used to assign GPS coordinates to your photos as well as to browse your photo archive based on location.

Searching your photos is the best quality control for your photo organizing. If you're not finding the photos you expect, then you might reconsider the kinds of metadata you're adding to your photos in the organizing phase. Do you wish you had more location information, such as City and State? Are you finding the people you expect to find? Are there keywords for important occasions such as birthdays, weddings, and graduations?

Exporting Photos

Now that you know how to find your photos, I hope you're excited to start sharing them and using them in creative projects. Given all the work you've done to deduplicate, curate, tag, and rename your photos, it's important to keep your organized photos safe. Think of your Family Photo Archive as a Master Archive that should be preserved and protected.

For example, if you want to convert a color photo to black and white, crop a photo for a print, or combine photos for a social media post, then you should do that with copies from your Family Photo Archive instead of the master images. By making temporary copies for your creative projects, you can always go back to the original master images for another

project or treatment, but you don't want to permanently edit, downsample, or lose the original quality of your master images.

Lightroom makes it easy to retain your master files and export derivative images for your creative projects. When you're done with your creative project, you can delete the temporary files and always have access to your master archive. Let's walk through an example:

1. I search my Family Photo Archive for photos of lighthouses with portrait orientation. I select three favorites that I want to print and frame.

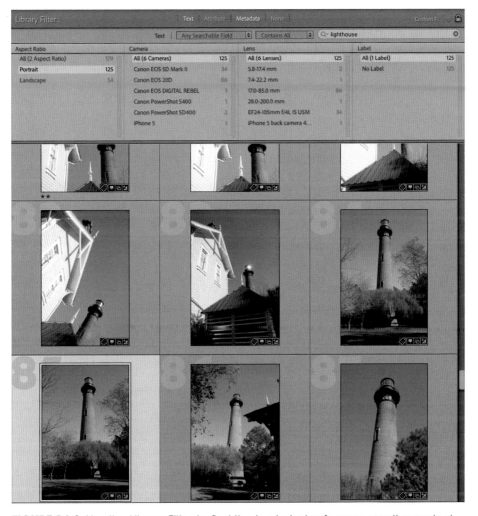

FIGURE 14.8 Use the Library Filter to find the best photos for your creative project.

2. I click the Export button in the bottom-left corner of the Lightroom interface and choose the following important settings:

 · I save the files to the Desktop.

 · I put them in a subfolder named something obvious like "lighthouse prints."

 · I set the file format to JPEG.

 · I set the quality to 75, which is almost always a great balance between quality and file size.

3. When I'm ready, I click the Export button, and Lightroom exports three JPEGs for me in a folder on the desktop. The original images are still in their folders in the archive where they belong.

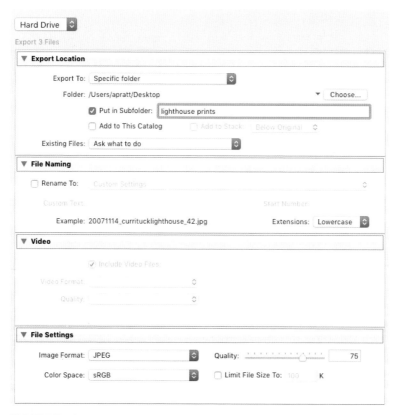

FIGURE 14.9 Export images for your creative project to a temporary folder.

4. I review the exported files and use them to order prints from my favorite photo print-ing service. I'm a big fan of Mpix, and if you want to save $10 on your first order use this link: **bit.ly/greatprints**.

5. After I've placed my print order, I can delete the "lighthouse prints" folder from my desktop because I probably don't need the image copies anymore. One exception would be that if I do extensive retouching or editing that I want to keep, then I can add the edited files to my Photo Archive.

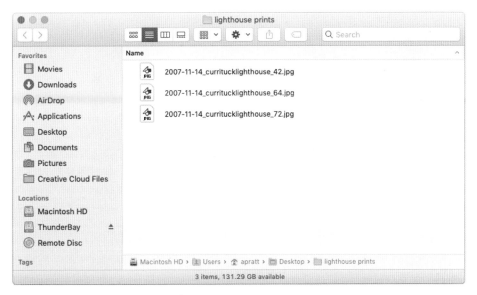

FIGURE 14.10 You can delete your temporary images when your creative project is complete.

Creative Projects

So much of the work I do is with computers, hard drives, and digital files. But the most sat-isfying part is when I turn all those organized photos into beautiful and memorable creative projects. A backup hard drive is necessary, but nobody cries tears of joy over a hard drive. Those feelings of gratitude and intense connection happen when somebody opens a pho-to book or hangs a stunning canvas print over the fireplace. I love organizing photos, but I don't feel like a project is complete until I can turn the photos into tangible creative projects that make my clients feel something.

The possibilities are endless, but these are a few of my favorite ways to share photos:

- **Photo Prints:** In our digital age, people are taking more than a trillion photos every year, but many people complain they never get to see and enjoy their photos. The simple act of printing photos is a great way to bring back the joy of photography and share memories with those you love.

- **Photo Restorations:** Sharing prints of modern photos is a lot of fun, but there's something special about restoring and printing vintage family photos. Whether you do it yourself or hire an expert, some color correction and digital restoration can go a long way in bringing back old memories.

- **Photo Enlargements:** Back in chapter 10, I made a big deal about high-resolution, archival scanning. This is important because a high-resolution file gives you more flexibility in how you can use your images, including photo enlargements. Most people think an 8 x 10-inch print is large, but I always encourage clients to go bigger. With decades of experience in photography and printing, I consider a 16 x 24-inch print in the medium range, and a 24 x 36-inch poster size is a fun way to enjoy great photos.

- **Mounted Prints:** One of my favorite ways to print a photo is as a mounted print on either matte board or styrene, which is a rigid plastic. I usually display prints on a picture ledge, but they can also be framed. If you plan to display mounted prints in the open, I suggest also adding a lustre coating to minimize fingerprints when people pick them up and enjoy them.

FIGURE 14.11 Mounted prints are great way to display your photos without the cost of framing.

- **Framed Prints:** A classic way to enjoy a photo print is framed with a matte. Choosing the right matte not only presents the photograph well, but also protects the print from adhering to the glass over time. If you're working with a vintage family photo, I suggest scanning, retouching, and making a new print for the frame while you keep the original in archival storage away from light, heat, and humidity.

- **Canvas:** Another timeless and durable way to present your favorite photos is printed on canvas and stretched over a wood frame. A good canvas vendor will ship your canvas ready to hang, and you might enjoy spending your money on a larger canvas instead of a frame. I display large canvases of some of my family's favorite photos throughout our home, and I rotate different sets to keep them fresh.

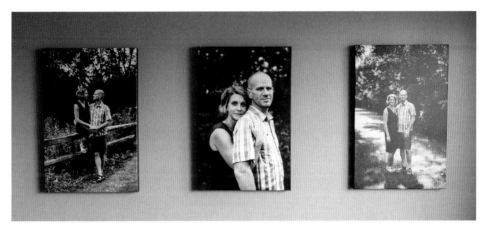

FIGURE 14.12 Canvas prints are a simple and stunning way to display your favorite photos.

- **Metal, Acrylic, and Wood Prints.** Many vendors can print your photos on unusual substrates, including metal, acrylic, and wood. I like metal prints for dark shots and night photography, acrylic for vibrant photos, and wood prints when I want a rustic look.

- **Slideshows:** I always find it powerful to see photos in motion or combined with video clips. You can create your own slideshows with software or websites, or hire a pro to celebrate major milestones, such as graduations, weddings, and retirements.

- **Photo Books:** I love designing photo books for clients using their freshly organized family photos. I suggest simple designs and classic materials, such as linen or leather covers, so your hard work is timeless and won't feel dated in a decade. One of my best tips for photo book design is to design square books. That way you can print a 10 x 10-inch or 12 x 12-inch book for yourself, and order gift editions at smaller sizes such as 8 x 8 inches without any rework of your layout.

FIGURE 14.13 Photo books are a memorable way to enjoy and share your family photos.

- **Email, Text, and Social Media:** We've run a survey about photo habits on the Chaos to Memories website for the last few years, and the number one way people like to share their photos is via text message. I guess it's hard to beat free and easy. While I love beautiful prints, canvases, and books, you can also share your photos digitally. Whether it's an endearing baby photo or an embarrassing college snapshot, use the searchable Family Photo Archive at your fingertips to let somebody know you're thinking of them!

I love organizing photos, but I consider the process a means to an end. My real goal is to share memories and connect people through photographs and the memories they capture. Therefore, I strongly recommend tangible photography for yourself and for gifts. Your searchable Family Photo Archive makes this easier than ever, and I hope the examples in this chapter inspire you to try at least one new way to share your photos.

15

Accessing Your Photo Archive

I love the peace of mind that comes with knowing all my family photos are curated, scanned, searchable, and safely backed up on multiple hard drives. But I don't bring a computer and hard drive everywhere I go. If I'm on vacation or out with friends, how do I share my photos?

To access your searchable Family Photo Archive from anywhere, I recommend the cloud services SmugMug (**smugmug.com**) or Flickr (**flickr.com**). These services offer unlimited storage for a fairly priced annual subscription, and you can search and enjoy your photos from anywhere, including on a smartphone, tablet, web browser, or smart TV.

FIGURE 15.1 We use SmugMug or Flickr for all Chaos to Memories Family Photo Archive projects because they offer unlimited storage and support search of industry-standard metadata.

Selecting a Service

There are lots of photo sharing sites and cloud services, so why do I recommend SmugMug and Flickr? I've researched and tested countless companies, and I've standardized on these two services based on the following criteria:

- **Metadata Standards:** If you follow the workflow in this book and add searchable metadata to your photos, all those keywords and captions will be searchable on either of these services. People are surprised to learn that many photo-sharing services don't retain or allow you to search industry-standard metadata, but it's a minimum requirement for me.

- **Original Quality:** When I upload and share my photos, I expect to retain the original resolution and quality of my photos. Both of these services retain the original quality, so I can order prints and share high-quality files from anywhere in the world.

- **Multiple Devices:** We live in a diverse digital world with many platforms, such as iOS and Android, macOS and Windows, and others. I use SmugMug and Flickr because they're accessible on virtually any computer, web browser, smartphone, or tablet. These services are even accessible on many smart TVs, so you can access your searchable Family Photo Archive on almost any screen.

- **Unlimited Storage:** I have a lot of photos spanning multiple generations, so I appreciate that these services offer unlimited storage. I keep taking new photos, but I don't have to worry about running out of storage space!

- **Low Price:** Both of these services are offered as annual subscriptions for very reasonable prices. Flickr offers a paid Pro account, and the SmugMug Basic account plan works great for most of my clients. I'm not listing the prices here in print because they'll probably change over time, but you can get a 20% discount on your first year of SmugMug with this special link: **bit.ly/smugmugdeal**.

- **Longevity:** As of the writing of this book, both services have been around for almost twenty years. That's like a century in the internet era, and they've outlasted countless other photo-sharing sites. I can't guarantee these are the best sites for your needs, or that they'll be around forever, but I use them for all my photos and client projects. Because I use these services for access and not backup, even if they shut down or I decide to switch services, I'm prepared. It would be annoying to upload all my photos again to a new service, but I won't lose anything because my Family Photo Archive is backed up safely on a hard drive that I'm responsible for.

Support for searchable metadata means all your organizing work is retained, and original quality means every pixel of your photo archive is available on any device. As you consider your options for accessing your Family Photo Archive, include the features above as important criteria in your research.

Account Setup

Even if you're not ready to commit to one of these services, you can try them both for free as part of your learning process. SmugMug offers a free 14-day trial, and Flickr offers a free account for up to 1,000 photos. Let's walk through an example using SmugMug.

1. **Create a trial account on smugmug.com.** All you need is your email address and a password, and you can try all the features for 14 days.

 FIGURE 15.2
 Sign up for a free trial account on SmugMug to test the service and learn the workflow.

 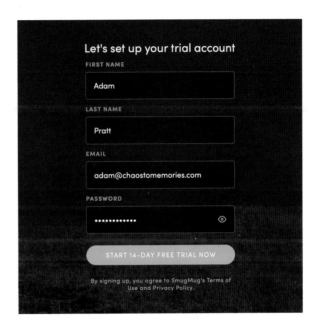

2. **Customize your privacy settings.** Log in to your account on SmugMug.com and navigate to Organize > Settings > Security & Sharing. Select Visibility, read the descriptions of each setting, and choose the option you're comfortable with. You might want to share all your photos with the world, or you might want to keep all your photos private for just you or your immediate family. The SmugMug service offers a variety of privacy options including public, unlisted, password-protected, and private galleries. If you're not sure how public you want to be with your photos, I suggest starting with the most restrictive options; you can always decide to loosen things up later.

FIGURE 15.3

Customize your gallery settings before you upload your photos.

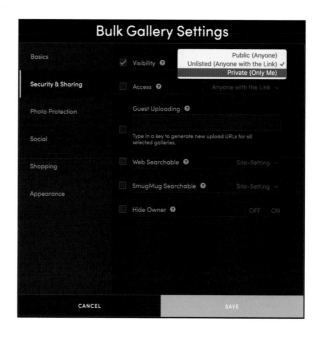

3. **Upload your photos.** There's a SmugMug plug-in for Lightroom that lets you sync your photos in Lightroom with your SmugMug account. You can download the free plug-in from **smugmug.com/features/apps**.

 Alternatively, you can upload large batches of images from your computer to SmugMug just using your web browser. A nice benefit to the web browser upload is that it's smart enough to retain nested folder structures, which is a big time-saver.

FIGURE 15.4

You can upload photos from your hard drive to your SmugMug account right from your web browser.

However you decide to upload your images to your SmugMug account, I suggest starting with some sample images that you know have searchable metadata. This way if your searching doesn't work as expected, you can verify your settings before uploading the rest of your Family Photo Archive.

Photo Search

After you have some of your photos uploaded to your SmugMug account, you're ready to test the photos-on-the-go experience.

1. You can access your SmugMug account from any web browser, smart TVs with Apple TV or Android TV support, iOS and Android tablets, and iOS and Android smartphones. Download and install the SmugMug app for your smartphone from the Apple App Store or the Google Play store.

2. Launch the SmugMug app and log in with your username and password.

3. You can browse your photos, including multiple folders and galleries, on your phone through the SmugMug app. However, I find it tedious to browse large photo collections on a small screen, so I prefer to use the search feature instead.

4. Click the Search icon, type your search text, and enjoy the results. Because SmugMug supports the same metadata standards as Lightroom, it's easy to search your photos for all the metadata—including keywords, captions, and locations—you added back in chapter 12. For instance, when I search for *homecoming* or *polka dots*, I get a photo of my wife and I from our high school homecoming dance wearing matching polka dots. A simple text search is my ticket to memory lane, anywhere and anytime. It's amazing that I can search and view my entire Family Photo Archive from anywhere, but the photos don't take up any storage space on my phone.

FIGURE 15.5

You can easily search your photos on SmugMug because the embedded metadata, such as keywords and captions, transfer from Lightroom to your SmugMug galleries.

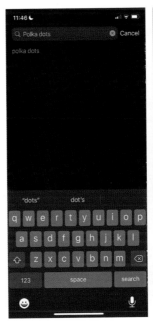
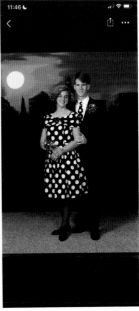

5. Once you've found a specific photo, you can do lots of things with SmugMug and your smartphone, including:

 • Text or email someone a link to the photo on your SmugMug account.

 • Post photos to social media accounts like Instagram.

 • Download a full-resolution file to the camera roll on your phone for further editing or sharing.

FIGURE 15.6
You can share your photos directly from the SmugMug mobile app through popular services such as text messaging and Instagram.

Videos

Throughout this book, I've focused on photos, but also offered tips on handling video. SmugMug and Flickr support video, but because their primary audience is photographers, their video support has some limitations. For example, SmugMug supports videos that are 20 minutes or shorter only, and Flickr hosts video files of only 1 GB or smaller. If your videos are all short clips, then you'll never notice these limitations.

However, if you have longer videos, such as your hour-long wedding video or other long-format clips, then you'll need a different solution. In this case, consider the following two options:

- You can edit your long videos into multiple shorter clips. Bite-sized chunks can make the long videos more viewable and can circumvent the limitations of these platforms. However, the editing process can be tedious and the viewing experience might be annoying.

- You can use a service dedicated to long-form video, such as YouTube. You've probably watched videos on YouTube, but did you know that you can post your own videos for free? Just create a free account on Google.com, log in to YouTube, and upload your longer video files. I love YouTube for personal video collections because it's free, you can access it on almost any device or screen, and you can control the visibility of your videos. I usually recommend the Unlisted option because those videos are easy for you to view and share, but strangers can't discover them without a direct link.

FIGURE 15.7
Upload your long video to YouTube for free and set the Visibility to Unlisted to create a private video gallery that's easy to share.

Visibility
Choose when to publish and who can see your video

⦿ **Save or publish**
Make your video **public**, **unlisted**, or **private**

○ Private
Only you and people you choose can watch your video

⦿ Unlisted
Anyone with the video link can watch your video

○ Public
Everyone can watch your video

☐ Set as instant Premiere ⓘ

A Different Approach

Most of the big tech companies including Apple, Google, Amazon, and Facebook want you to capture, edit, organize, and share your photos on your phone with their service. It's their business strategy to keep you using their services, watching their ads, and paying their subscriptions. Unfortunately, these popular services don't support the metadata standards that help ensure your photos will be accessible for future generations. Frankly, they care more about their platform than your photos.

Alternatively, the workflow you've learned throughout this book is based on industry standards and photo management best practices that let you access your photos from anywhere and for years to come without being locked in to one company, phone, app, or platform. You can keep taking photos with your phone, point-and-shoot camera, or DSLR, but you'll:

- Manage them on your computer
- Back them up to a hard drive
- Sync them to the cloud and access them anywhere

Because you're using the best apps and services for different parts of the workflow, you can lose a phone, upgrade a computer, or replace a hard drive without breaking your system. Unlike the frustrating photo chaos most people have on their phones, this workflow offers a different way that's effective, enjoyable, and permanent.

PHASE 5:
Maintain

Photo organization is not a one-time event, but an ongoing process. As long as you keep taking photos, you need to keep organizing. The maintenance phase is a compressed version of the other four phases that you can use to catch up on a regular basis. Maintenance can be done daily, weekly, monthly, or quarterly, but I suggest you catch up at least four times per year using the organizing workflow you've learned throughout this book.

16

Maintaining Your Photo Archive

The workflow you've learned throughout this book to declutter, organize, and enjoy your photos gives you a clear process to tackle your photo backlog. It's often a big project, and it takes a long time to catch up on the years, decades, or even generations of photos you want to preserve and enjoy. But that's all looking back in time.

After (or while) you catch up on your old photos, how are you going to handle the new photos you keep taking? The fifth and final phase of my workflow is all about maintaining your Family Photo Archive. In essence, you'll use the same organizing workflow on new images, but you'll work in small batches of new photos instead of big batches of old photos. After you're caught up on the old stuff, maintaining the new stuff is much easier and less overwhelming.

Maintaining your Family Photo Archive with new photos is easier than organizing your old photos for four reasons:

- **You're working in smaller batches.** Our average Chaos to Memories client has 10,000 physical photos and more than 100,000 digital photos, but if you maintain your photo archive on a regular basis, you'll be working on batches of dozens or hundreds (maybe a thousand), which is much more manageable.

- **You've developed new skills and habits.** Through the process of organizing your photo backlog you'll get more comfortable with deleting duplicates, more decisive about curating your best shots, and more efficient in applying searchable metadata.

- **The photos are more recent.** Organizing old photos demands a lot of your memory, and working with photos from previous generations can require extensive research. It's a labor of love, and it's a slow process. By comparison, organizing your latest photos is much easier because they're recent experiences and your memory is fresh.

- **Adobe Lightroom Classic is getting smarter.** Did you know that Lightroom has features that are powered by artificial intelligence and machine learning? That means Lightroom learns the nuances of faces in your archive and the keywords you use most frequently. The longer you work on a catalog of photos in Lightroom, the more accurate the software becomes at identifying faces, suggesting keywords, and auto-completing locations, which makes your maintenance faster, easier, and more consistent.

FIGURE 16.1 Adobe Lightroom Classic gets more accurate at identifying faces the more you use it.

Tidy Up Your Digital Past

After all your old digital photos are curated, organized, and backed up, you should tidy up your old files and storage. If you don't tidy up your digital photos, there's a risk that you'll inadvertently mix in your old cluttered files with your decluttered Family Photo Archive, and it would be a shame to lose all that great work.

When you're certain your backups are complete and safe, I suggest these six steps to tidy up your digital past:

1. **Format old memory cards.** If you gathered all your digital files back in chapter 4, then there's no need to keep old memory cards that only work in a camera you don't own anymore. Any memory cards that are small or incompatible with your current camera should be formatted and either recycled or donated. If the cards are modern and have usable storage, then you should format them and keep them in your camera bag for your next vacation, birthday party, or photo walk.

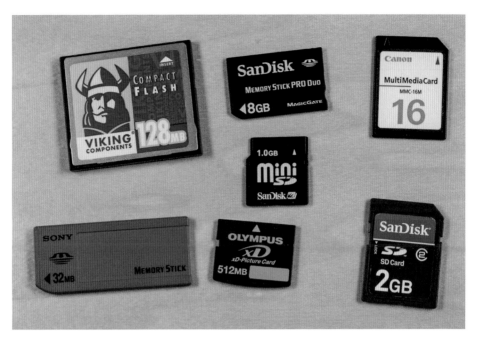

FIGURE 16.2 Format old memory cards before you re-use, recycle, or donate them.

2. **Format and recycle old hard drives.** After you've gathered all your photos and other important files from your old hard drives, they should be erased and recycled. Keeping these around adds to your clutter and increases risk to your digital privacy. You can format them with your computer, but for enhanced security and drama, you can also drill a hole through the top of the drive with a power tool. One hole will render it unusable, unreadable, and ready for recycling.

3. **Destroy old CDs and DVDs.** If you have DVDs that still work in a DVD player, you might keep those, but the rest of your homemade optical discs should probably go. Use a utility knife to make a few deep scratches on the top of the disc or cut the edge of the disc with a sturdy pair of scissors to make it unreadable. Recycling services for optical discs are hard to find, but destroying the disc before you discard it eliminates the privacy risk.

FIGURE 16.3 Damaging an optical disc with a utility knife or pair of scissors before throwing it away makes it unreadable.

4. **Delete old photos from phones.** If the photos from your phone have been gathered, deduplicated, curated, and organized, then you don't need to keep them all on your phone. This can save space on your phone, save money on cloud storage, and lengthen the time between phone upgrades. And if you follow my complete work-flow, all your photos are safe, organized, and accessible in your SmugMug or Flickr account. They don't need to be taking up space on your phone.

5. **Disable unwanted sync.** I meet a lot of people who have photos from their phone or computer syncing to iCloud, Google Photos, Amazon Photos, Dropbox, OneDrive, and more. Some folks have their photos synced to all these services at once! When I ask them why, they usually shrug their shoulders sheepishly and say, "Because I could." I'm a big fan of backups, but syncing to multiple services actually adds to your digital clutter.

6. **Empty and close cloud accounts.** A financial planner will tell you to cancel old credit cards and close accounts you don't use anymore because they're a temptation, se-curity risk, and a hassle to manage. Cloud accounts and service subscriptions are the same way. If there are sites you won't be using anymore, it's time to delete your files from those services, close your accounts, and maybe save some money.

New Workflow for New Photos

Now that your old and outdated sources are retired and recycled, you can focus all your attention on your new Family Photo Archive. Let's walk through your maintenance workflow for new photos.

1. If you're using a digital camera (point-and-shoot, DSLR, etc.), then make sure the battery is charged and set the date and time accurately. Correct date and time settings on your camera make chronological organization a breeze. If you mostly take photos with your smartphone, you can skip this step because your phone always knows the accurate time based on the cell towers in your phone network.

FIGURE 16.4

Setting the correct date and time in your camera makes it easier to organize your photos later.

2. If you're using a digital camera, then format your memory card with your camera before your next photo session. One of the most common photo mistakes I see is people deleting photos from the memory card instead of using the format function. It might seem like the same thing, but formatting a card deletes the photos and prepares the card in a fresh state that will make it more reliable. Another common mistake is formatting the card on your computer; you should always format the card in the camera that you're going to shoot with. These steps help ensure the reliability of your card, and you'll avoid the risk of importing duplicates from a previous shoot. If you're shooting photos with your smartphone, you don't need to format the phone, but make sure you have enough available storage to capture new photos.

FIGURE 16.5

Formatting your memory card in your camera ensures free space, minimizes the risk of image corruption, and avoids duplicates.

3. Capture your photos on the phone or camera of your choice. After you've deleted thousands of duplicates and duds, I suspect you'll compose more thoughtfully and shoot more purposefully than before. Let the curation strategies you learned in chapter 11 affect how you shoot in the future.

4. On a regular basis, import your digital photos directly to your computer with Adobe Lightroom Classic. Open your Lightroom Catalog and connect a memory card reader, smartphone, or tablet. Click the Import button in the bottom-left corner of the Lightroom Library module, choose your phone or memory card as the Source device on the left side of the interface, and import photos by date using the Destination settings on the right side of the Import dialog. If you need a refresher on the Import process, check out the details in chapter 6 (pages 59–61).

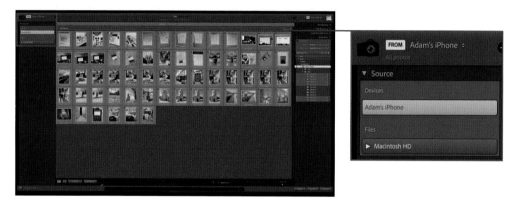

FIGURE 16.6 On a regular basis, import your photos from your memory cards and phone directly to your Lightroom catalog.

> **TIP** Many people copy their digital photos to their computer with other apps, and then import those photos to Lightroom. That two-step process is unnecessary, so skip the slow line and import directly from your device to your Lightroom catalog.

5. Back up your photos right away. If you download photos from a memory card, format the memory card, and start shooting again, then the only copy of those new photos is in your Lightroom catalog. A good backup strategy protects against human mistakes and technical failures, so I recommend making a backup right away, especially if you don't have time to organize.

6. It's time to delete the duds, curate the best, and delete the rest. If you've organized your backlog of photos, then you've had lots of practice with this process and you should feel more comfortable than when you started. Remember, the goal is a curated archive of your favorite photos, not a cluttered collection of every photo you've ever taken. Revisit chapter 11 if you want a refresher on curation best practices.

7. Now you're ready to organize the best photos you've decided to keep. This step involves adding searchable metadata (faces, places, events, etc.) and renaming

the final files and folders. And because your camera settings are correct and your memory cards are fresh, you shouldn't have to deal with fixing any incorrect dates or times, and the organizing process will be simpler than ever! Organizing requires discipline, but maintenance is always easier than dealing with a backlog of decades of photos. Check out chapter 12 if you want to review the process of organizing photos.

8. After your photos are organized, make a fresh backup of your updated Family Photo Archive. If you use one of the backup software apps I recommended back in chapter 4 (page 43), the backup will copy only the new files and the process should take just a few minutes.

9. If you've decided to use a photo sharing service like SmugMug or Flickr, then you'll want to upload your new batches of organized photos into your account. This ensures you have access to your best photos from anywhere. You can review those steps back in chapter 15.

10. Don't forget to share your photos! One of my clients told me that a recipe gets better the more you share it, and I feel the same way about photographs. It could be as simple as a text message or as beautiful as a canvas gallery wrap, but there are many thoughtful and creative ways to share your photos. Chapter 14 gives you ten of my favorite ideas for sharing your photographs with people who are important to you.

Maintenance Best Practices

Maintaining your Family Photo Archive is the disciplined process of staying on top of your photos so you can enjoy them today and pass them on to future generations. There's not much new in this chapter, but I hope a condensed review of the workflow gives you clarity and confidence as you look to the future. Before we wrap up, I want to share a few best practices that will help you in the days ahead:

· **Designate a librarian.** For better or worse, Lightroom is designed as a single-user app and two people cannot work on the same catalog at the same time. Even it was technically possible, it would be like too many cooks in the kitchen and you'd probably get yourself in trouble. I encourage you to designate one person as the librarian of your Family Photo Archive to avoid conflicts and ensure consistency. If you read this book, then you're probably the librarian.

· **Set a schedule.** Maintenance requires discipline, and having a set schedule will help you stay on top of your photos. The frequency of your maintenance will depend on how much and how often you shoot. Professional photographers and snap-happy shooters might need to download and organize photos every day or two, while others might be able to organize weekly or monthly without getting too behind and overwhelmed. You don't have to hit your schedule perfectly, but it helps to have a goal.

- **Don't be creative.** I love the creativity of photography and sharing my images, but organizing should not be a creative process. When it comes to organizing and maintaining your Family Photo Archive, stick to the workflow. By consistently following this efficient workflow, you'll be able to organize faster and spend your energy where it matters: taking better photos, curating the best ones, and sharing them with others.

- **Document the project.** Decluttering and organizing a Family Photo Archive is a very meaningful project, but it also requires a lot of energy and attention to detail. Sharing a copy of the archive with loved ones or passing it on to future generations is a unique blessing, and a project summary can help others understand this special gift. At Chaos to Memories, we print a customer project report for large client projects, but even a simple text file or PDF can document the project. For example, you can write about who organized the photos, when, how, and why. In Lightroom, use the Metadata > Export Keywords... command to export a list of all the keywords (including names) you used to make the photos searchable. If you're retaining the physical photos (prints, negatives, slides, etc.), include a note about where those can be found. Document your photos like you would your finances so your loved ones can inherit your photo legacy.

FIGURE 16.7 Document your photo project for your own records and future generations.

Thank You

I love organizing photos for my family and clients, and I hope this passion has been evident as you've read these chapters. I'm grateful you spent this time with me and hope the system I've developed over the last twenty-five years gives you a workflow for decluttering your photo life, organizing your favorites, and sharing your memories.

Searchable photos and organized boxes feel peaceful to me, but it's only a means to an end. My deeper goal has always been for you to enjoy your photos instead of feeling overwhelmed by them. One of the best ways to enjoy a photo is to share it with people you love, so start doing that today. You can share photos along the way as you implement this workflow instead of waiting until you're done. In fact, sharing throughout the process is a great way to involve others in the experience and keep yourself motivated.

As this book comes to a close, I want to share one of my favorite photos from my Family Photo Archive. My friend Carolyn Walter shot this family portrait a few years ago at a local arboretum. I appreciate her photography, and this image reminds me of the people I love most and my motivation for doing this work. We all want to remember, and to be remembered. My hope is that through our Family Photo Archive my children will remember that God has blessed them and that their parents love them! What are your hopes, and how will you share your photos with others?

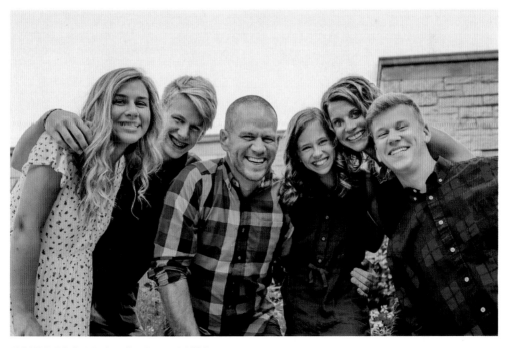

FIGURE 16.8 My family, August 2019

Resources

Apps and Plug-Ins

dupeGuru is a fast, flexible, and free deduplication app that I use on every project. **dupeguru.voltaicideas.net**

Duplicate Finder is a free, cross-platform deduplication plug-in for Adobe Lightroom Classic. **bungenstock.de/teekesselchen**

PhotoSweeper is a popular, affordable macOS-only deduplication app. **overmacs.com**

Duplicate Cleaner Pro is a top Windows-only deduplication app. **duplicatecleaner.com**

SuperDuper is excellent backup software for macOS. **shirt-pocket.com/SuperDuper**

Acronis Cyber Protect is an excellent backup utility for Windows computers. **acronis.com/en-us/products/true-image/**

iMazing for macOS and Windows makes it easy to copy photos and videos from iPhones and iPads to your hard drive. **imazing.com**

Visit **takeout.google.com** for the easiest way to gather your digital photos from the Google Photos service.

Metadata Fixer is an inexpensive app that helps you retain searchable descriptions after you download digital photos with the Google Takeout service. **metadatafixer.com**

If you need to gather digital photos from the Amazon Photos service, download the Amazon Photos desktop app to your computer from **photos.amazon.com**.

The Photos Takeout app makes it easier to extract your digital photos from the Apple Photos app and retain some of the searchable information including keywords. **photostakeout.com**

CopyTrans Cloudly is a great Windows app for gathering digital photos from Apple's iCloud. **copytrans.net/copytranscloudly**

Backblaze is a good choice for cloud-based off-site backups. Sign up for this service at this link and get one month free: **bit.ly/3Jh3x7k**.

Big Mean Folder Machine is a macOS-only app that will sort your digital photos into subfolders based on their capture dates. **publicspace.net/BigMeanFolderMachine**

PhotoMove for Windows is another app for sorting digital photos by capture date. **mjbpix.com**

Negative Lab Pro is a powerful Lightroom plug-in for converting scanned photographic negatives. **negativelabpro.com**

Adobe DNG Converter is free software for macOS and Windows that converts hundreds of proprietary camera raw formats to the universal DNG format. **helpx.adobe.com/camera-raw/digital-negative.html**

iMazing HEIC Converter is a free app for macOS and Windows that converts the HEIC/HEIF file format to the more universal JPEG format. **imazing.com/heic**

GraphicConverter is a macOS-only app that converts the orphaned Kodak Photo CD format to standard TIFF or JPEG files. It's also a great all-purpose batch conversion utility. **lemkesoft.de/en/products/graphicconverter/**

Photo Services

Mpix is a great photo printing service. Save $10 off your first order with this link: **bit.ly/greatprints**.

SmugMug is our choice at Chaos to Memories for almost every client project; you can save 20% off your first year of this photo sharing service with the link: **bit.ly/smugmugdeal**.

Download the free SmugMug plug-in for Lightroom from **smugmug.com/features/apps**.

Flickr is another great photo sharing service with unlimited storage. **flickr.com**

Visit the Chaos to Memories website for other photo organizing courses and resources: **chaostomemories.com**

Archival Storage Companies

Conservation Resources International is my favorite source of archival storage supplies. **conservationresources.com**

Archival Methods is another great vendor of archival storage supplies. **archivalmethods.com**

Print File is my favorite source of negative sleeves, and they offer other archival storage supplies. **printfile.com**

Learning Resources

Download my free Camera Scanning Gear Guide from my website: **chaostomemories.com/camerascanning**

Index